IMAGES
of America

THE PENNSYLVANIA
TURNPIKE

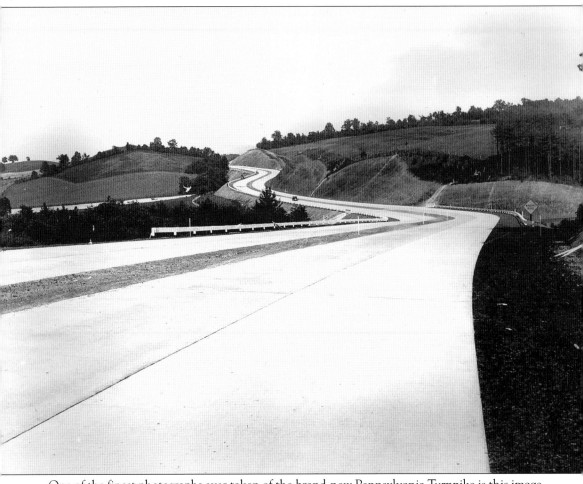

One of the finest photographs ever taken of the brand-new Pennsylvania Turnpike is this image of a series of curves just east of the Fort Littleton interchange. Taken in 1940 and now housed in the Pennsylvania State Archives, the photograph dramatically captures one of America's most famous highways.

On the cover: Motorists make the difficult climb up the eastern face of Allegheny Mountain in the 1940s.

IMAGES
of America

THE PENNSYLVANIA TURNPIKE

Mitchell E. Dakelman and Neal A. Schorr

ARCADIA
PUBLISHING

Published by Arcadia Publishing
Charleston SC, Chicago IL, Portsmouth NH, San Francisco CA

Printed in the United States of America

Library of Congress Catalog Card Number: 2003117076

For all general information contact Arcadia Publishing at:
Telephone 843-853-2070
Fax 843-853-0044
E-mail sales@arcadiapublishing.com
For customer service and orders:
Toll-Free 1-888-313-2665

Visit us on the Internet at www.arcadiapublishing.com

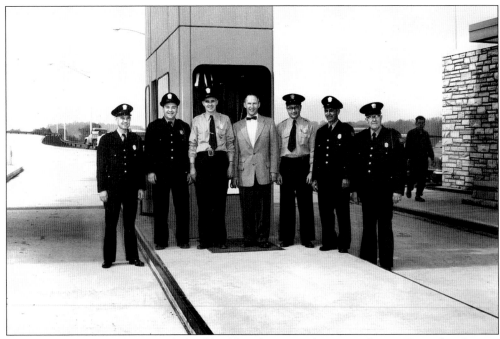

Thousands of men and women helped build and operate the Pennsylvania Turnpike. Among them were these toll collectors posing at the brand-new Philadelphia interchange tollbooth in 1954.

CONTENTS

Acknowledgments 6

Foreword 7

Introduction 9

1. The South Pennsylvania Railroad 11

2. From Railway to Highway 21

3. Building the Pennsylvania Turnpike 29

4. The World's Greatest Highway 69

5. Spanning the State 85

6. Four Lanes All the Way 109

7. The Turnpike Since 1970 121

ACKNOWLEDGMENTS

The authors would like to thank the following individuals and fans of the World's Greatest Highway for their assistance in the creation of this book: John Bibber Jr.; the late Bryce Brown; Branden Diehl of the Southern Alleghenies Conservancy; John "Tunnel" Foor; Michael Groff; Don Hensley; Jean Hill; Russ Love; the late Charles Martz and his wife, Ruth Martz; Beth Moroney; Linda Nyman; Charles F. Schneider; Michael Sherban; Nancy Sommers; and the infinitely patient Kimberly Schorr, wife of co-author Neal A. Schorr.

We would also like to thank our friend Dan Cupper, author of *The Pennsylvania Turnpike: A History*. His book proved invaluable in the confirmation of various facts and figures during the preparation of this volume.

Finally, the authors would like to acknowledge the inspiration provided by William H. Shank, author of the book *Vanderbilt's Folly*, written some 40 years ago. His work helped spark their interest in the Pennsylvania Turnpike long before they had ever met each other.

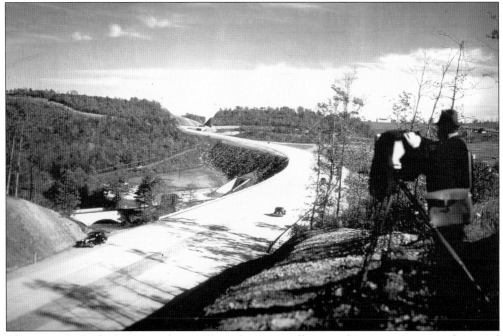

The men who built the Pennsylvania Turnpike were well aware that it was a tremendous civil engineering achievement. Eager to document the building of the new highway, they dispatched photographers to capture the construction of the project on film, as in this view near Everett. Little did they realize what impact the turnpike would have on America.

FOREWORD

Sometime in the spring of 1985, I received a letter from a fellow by the name of Mitchell Dakelman. He had read an article that I had written describing my model railroad, which portrayed the South Pennsylvania Railroad. The roadbed of the South Penn would eventually be used for the construction of the Pennsylvania Turnpike, a highway with which both of us had a tremendous fascination. Mitch's letter told me of his interest in the turnpike, and he concluded by saying that we could probably be very good friends.

How prophetic his letter was! Almost 20 years later, I count Mitchell among my closest of friends, primarily because of our mutual interest in the Pennsylvania Turnpike. Over the years, we have made countless trips to the turnpike commission's facilities (which house their historical material), to the Pennsylvania State Archives, and to the Pennsylvania Turnpike itself. In the course of our research, we have accumulated thousands of documents, photographs, and pieces of memorabilia pertaining to the Pennsylvania Turnpike.

During this time, Mitch and I have developed friendships with numerous other individuals who share our love of the turnpike. Each of us has a specific interest in the turnpike. Some of us like to explore the right-of-way of the South Penn. Others collect turnpike memorabilia or have a passion for turnpike maintenance vehicles. My personal interest lies in researching the engineering of the highway.

Mitch's love is perusing the archival photographs of the turnpike commission, now in the possession of the Pennsylvania State Archives. Over the years, Mitch has collected, printed, and organized a huge collection of turnpike images and motion pictures. Among Pennsylvania Turnpike aficionados, he is recognized as having assembled the finest collection of archival material pertaining to the nation's first superhighway.

The majority of the images in this work are a result of Mitchell's efforts at the Pennsylvania State Archives, which is the source of all uncredited photographs. When another identifiable source has been used, it is clearly noted in the photograph's caption.

For many years, Mitchell and I have talked of writing a book about our favorite highway using his collection of photographs and my knowledge of highway engineering as its foundation. With the publication of this book, we have turned that dream into a reality. We sincerely hope that you will enjoy this photographic history of the World's Greatest Highway.

—Neal A. Schorr
February 2004

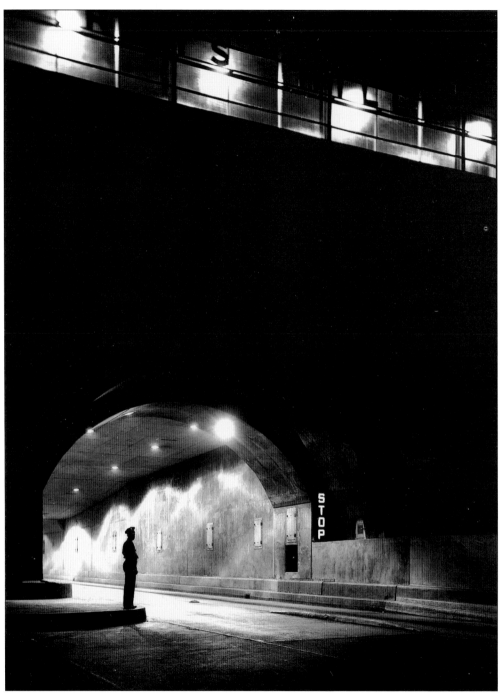

When the Pennsylvania Turnpike opened on October 1, 1940, the seven tunnels captured the imagination of the public more than anything else did. Lending a sense of romance and excitement to the new highway, they helped ensure the project's success and its place in history. In this dramatic photograph taken by photojournalist Arthur Rothstein, a tunnel guard patrols Rays Hill Tunnel. (Library of Congress.)

INTRODUCTION

In today's world, the automobile is the primary means of transportation in the United States. In fact, there can be no doubt as to its profound influence upon the shaping of our nation in the 20th century.

The world of 1900 was a very different place. The railroad was the principal method of transportation for the vast majority of Americans. Within cities, citizens traveled to work by means of trolleys and local trains. Intercity travel was by means of the long-distance trains of railroads such as the Pennsylvania, New York Central, and Santa Fe—all of which are now long gone. The horseless carriage was in its infancy, and the roads upon which automobiles traveled were little more than muddy paths.

One hundred years later, passenger trains were but a ghost of their former glory. The automobile had become the nation's primary means of transportation. Commuters journeyed to work on complex systems of urban freeways, and the nation's cities were linked by the Interstate Highway System, the largest public works project in the history of mankind.

Of all the highways constructed during the 20th century to serve the automobile, one stands alone. That highway is the Pennsylvania Turnpike. The Pennsylvania Turnpike most certainly was not the first "express highway" ever built. That honor goes to the Bronx River Parkway, which was constructed in the 1920s north of New York City. Indeed, a number of others were built before the opening of the Pennsylvania Turnpike in 1940. These include Germany's autobahns and Connecticut's Merritt Parkway.

While the importance of these highways cannot be denied, none of them came close to the accomplishment of the Pennsylvania Turnpike. In one fell swoop during the autumn of 1940, some 160 miles of brand-new highway were opened across southern Pennsylvania. Never before had such a long expanse of roadway been suddenly placed into service. Furthermore, it traversed some of the most mountainous terrain in the eastern United States. All the while, it adhered to rigorous and consistent engineering standards throughout its length, while pioneering the latest advances in highway design.

The new highway immediately captured the imagination of the motoring public. No one had ever seen a highway the likes of the Pennsylvania Turnpike. Adding to the mystique of the turnpike were its seven tunnels. The names Kittatinny, Tuscarora, and Sideling Hill suddenly became famous, and images of the tunnels were captured on postcards and souvenirs sold at the service plazas along the highway.

The turnpike proved to be a smashing success, with the number of vehicles using the highway far exceeding projections. Traffic volume grew annually, with the exception of the years during World War II. So successful was the new highway that the bonds issued by the turnpike commission were often said to be "as good as gold."

It is through the success of the Pennsylvania Turnpike that its place in history may be understood. The initial attempts of the turnpike commission to float bonds to finance the highway during the Depression years of the late 1930s were a failure. The skeptics asked who would possibly use a $70 million highway through the middle of nowhere. It was only when Pres. Franklin Roosevelt stepped in that the project could finally get off the ground.

Recognizing the potential military value of the highway, he directed the federal government to help finance the turnpike. Only then was the future of the project secured.

The hordes of motorists traveling the turnpike not only dispelled the fears of the skeptics but also proved the viability of the long-distance intercity express highway and launched the most massive period of highway construction in history. By 1956, the Pennsylvania Turnpike stretched for 360 miles, from New Jersey to Ohio. It spurred the postwar "toll road movement," including the construction of the Maine Turnpike in 1947 and the better-known New Jersey Turnpike and New York State Thruway in the 1950s. By 1960, it was possible to drive between New York City and Chicago without ever encountering a traffic light.

In 1956, Congress authorized the construction of the Interstate Highway System, based on the success of this rapidly expanding network of toll roads. The Interstate Highway System would eventually connect the nation's cities and states and would carry the vast majority of its long-distance automobile and truck traffic.

Therein lies the legacy of the Pennsylvania Turnpike. While, undoubtedly, long-distance express highways would have eventually been built across the United States, it was the turnpike that so dramatically and powerfully proved the viability of the concept. Without its success, the construction of such intercity highways would have probably occurred at a much slower pace. The resulting changes in the American way of life would have materialized much more slowly as well.

Furthermore, the turnpike's adherence to rigid engineering standards has allowed the highway to stand the test of time. Witness the fact that, with the exception of a few short stretches of urban expressway, it is the only highway constructed before World War II that has ever been incorporated into the Interstate Highway System. It was not just an idle boast when the turnpike referred to itself as the World's Greatest Highway.

As the years passed, the turnpike's claim became more of a promotional slogan than a statement of the truth. Nevertheless, the turnpike remains as vital as ever, and traffic volumes continue to increase year by year. Various modernization programs have been implemented over the years. The most significant has been the bypassing or double tunneling of the seven original bores. The classic turnpike overpasses have been gradually replaced with modern utilitarian structures, and the Philadelphia section has been widened to six lanes. Also, a number of new extensions have been built at the direction of the state legislature.

The Pennsylvania Turnpike promises to continue as a major transportation artery for years to come. It has clearly earned its place in American history, and its impact on our way of life cannot be overestimated.

One

THE SOUTH PENNSYLVANIA RAILROAD

By the late 19th century, railroads had become the predominant means of transportation in the United States. They were, in fact, the linchpins of the industrial age, becoming as important to the American economy as were the very industries they served. Those who owned and controlled the railroads became wealthy and powerful. As a result, investors and speculators were constantly acquiring existing railroads or building new railroads during this era.

One such example was the South Pennsylvania Railroad. Originally known by a variety of names, this line was first proposed in 1854, and its goal was to connect Harrisburg to western Pennsylvania. The route to be followed was the southernmost of three that were first laid out as possible routes for the Pennsylvania Railroad. Following ridge lines, avoiding major river crossings, and striking all major mountain ridges at right angles, the route of the South Penn was recognized as one of the most brilliant railroad surveys ever conducted. Unfortunately, by the 1880s, little more had been accomplished other than the grading of a few miles of the eastern end of the line.

At the same time, the Pennsylvania and New York Central Railroads had emerged as fierce competitors in the east, both vying for as much rail traffic as they could possibly attract to their lines. The Pennsylvania took direct aim at the Central by backing the construction of the West Shore line across New York State. The New York Central counterattacked by assuming control of the barely started South Penn. Finally, the South Penn had the financial resources to become more than just a dream.

In 1883, at the direction of William Vanderbilt of the New York Central, work began in earnest on the South Penn. Thousands of workers poured into the woods of southern Pennsylvania to construct the new railroad, including nine new tunnels.

Over the next two years, many miles of roadbed were graded through the Pennsylvania mountains. Cut-stone culverts allowed the new line to pass over small streams, and piers sprouted from the Susquehanna River for a new bridge. Thousands of feet of tunnel were bored, and portals and tunnel liners were constructed by skilled stonemasons.

Then, in 1885, the famed financier J. P. Morgan entered the picture. Realizing that the competition between the two railroads would be self-defeating, he persuaded both lines to agree to a truce. The Pennsylvania conveyed control of the West Shore to the Central and acquired the South Penn. With an agreement now in place, all work was stopped on the South Penn, never to be resumed. Picks and shovels were left to rot in the woods as the men who had toiled on the South Penn walked off the job.

Over the next 50 years, multiple attempts were made to revive the South Penn. Not one succeeded. By the time the South Penn was abandoned, it had achieved the dubious distinction of being the railroad project that came closest to completion in the United States without actually being finished.

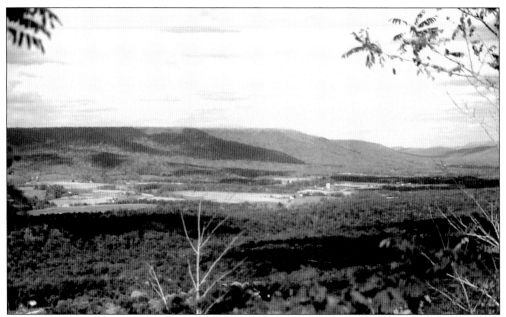

The Appalachian Mountains were formed millions of years ago by the upheaval of the earth's crust. As long as man has inhabited North America, the mountains have been a barrier to east–west travel. The Europeans who came to settle the New World found them to be so overwhelming that they named them the Endless Mountains. (Neal A. Schorr.)

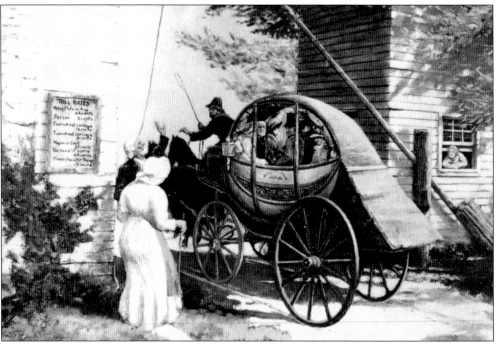

The Native Americans who inhabited North America before the arrival of the European settlers traveled across the Appalachians by means of trails through the wilderness. As the settlers moved westward and displaced the Native American tribes, they cut roads across the mountains to accommodate horses and carriages.

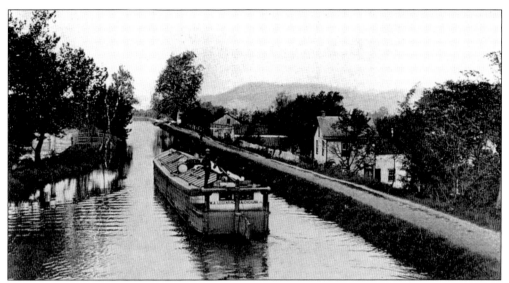

With the opening of the Erie Canal in 1825, Philadelphians demanded that a canal be built across Pennsylvania as well. The result was the Pennsylvania Mainline Canal, opened in 1834. A cumbersome mix of canal, railroad, and inclined planes, it was never particularly successful. The slow and sometimes dangerous journey on the canal prompted calls for a railroad to be built across the commonwealth.

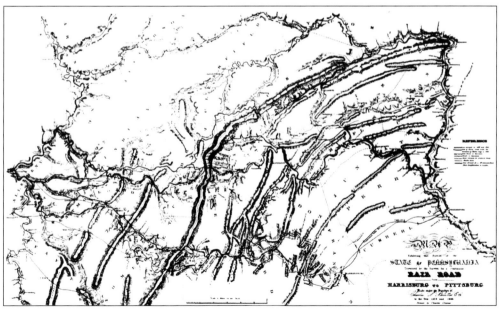

In 1839, the commonwealth retained Col. Charles Schlatter to map out potential routes for a railroad across Pennsylvania. He proposed three alternatives. The northern route, though having the easiest grades, was by far the longest. The southern route was the shortest but had the steepest grades. The middle alternative was the best compromise between mileage and grades and was chosen as the route to be used for the construction of the Pennsylvania Railroad.

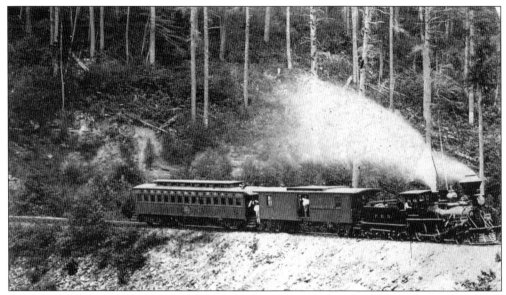

By the 1880s, the Pennsylvania and New York Central Railroads had emerged as industrial powerhouses and fierce rivals. As part of the war between the two giants, the Pennsylvania backed the construction of the West Shore Railroad across New York State, in direct competition with the New York Central. The Central sought to retaliate by constructing a new railroad, the South Pennsylvania, along Schlatter's unused southern route. (National Railway Historical Society.)

William Vanderbilt of the New York Central was the driving force behind the construction of the South Pennsylvania Railroad. He saw the South Penn as a means of taking rail traffic away from the Central's rival, the Pennsylvania Railroad. He received the financial backing of some of the Pennsylvania's customers, such as Andrew Carnegie, who were unhappy with the high shipping rates charged by the railroad.

George Roberts was the head of the Pennsylvania Railroad in the mid-1880s, when the South Penn was being built. Enraged by the New York Central's blatant attack on his own railroad, he pushed ahead with construction on the West Shore Railroad. This line paralleled Vanderbilt's New York Central within New York State and threatened to drain traffic from it.

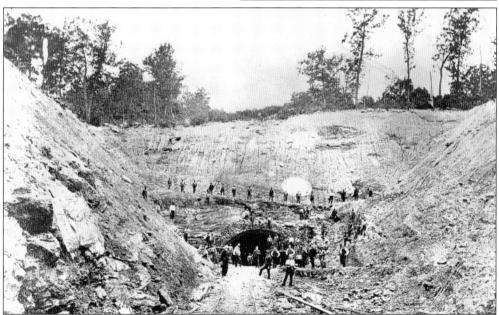

Only a few photographs of the South Pennsylvania Railroad are known to exist. This image shows the eastern portal of Rays Hill Tunnel during construction. Andrew Carnegie, one of the principal financial supporters of the project, is believed to be among the group of men posing at the construction site.

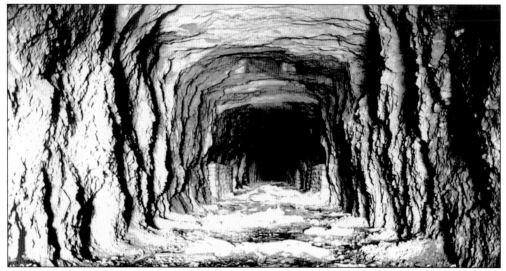

Years after the railroad's abandonment, postcards were published of its ill-fated tunnels. This one illustrates the interior of one of the bores. All of the tunnels were to be lined with cut stone that was quarried locally. As seen in this 1905 view of Blue Mountain Tunnel, work had already begun on the stone lining.

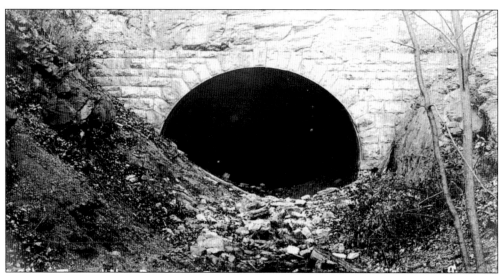

As is evident in a different postcard view, some of the tunnel portals were actually completed. This is another 1905 image of Blue Mountain Tunnel. The photograph is labeled "Tunnel Near Roxbury PA" after a nearby town.

The famed financier J. P. Morgan was well aware that completion of both the South Penn and West Shore lines would result in self-destructive competition between the two lines. He therefore brought together Vanderbilt and Roberts and convinced them to end their conflict. The Central took control of the West Shore line, while the South Penn was awarded to the Pennsylvania Railroad. As there was no use for the partially completed railroad, all work on the line ceased forever.

Shortly after Morgan brokered the agreement between Vanderbilt and Roberts in the summer of 1885, an order was issued to cease all work on the South Penn. The laborers who had toiled on the project for two years walked off the job, and the project was abandoned. Many miles of roadbed quickly became overgrown with vegetation. Shown here is a section of the old roadbed just east of Allegheny Tunnel (seen through the trees to the right) over a century later. (Mitchell E. Dakelman.)

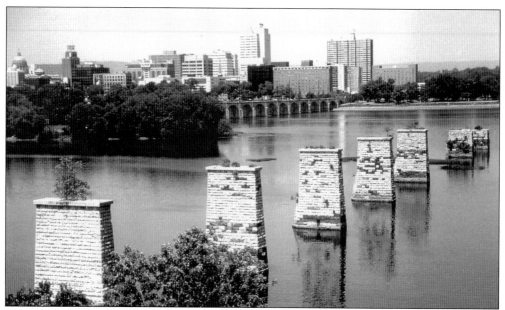

The most obvious vestige of the South Penn was the series of bridge piers that studded the Susquehanna River at Harrisburg. Although they were completely finished by the time of the South Penn's abandonment in 1885, not a single piece of steel was ever set upon them. Most were eventually removed so that the stone could be reused by the Reading Railroad. Those left untouched still stand today. (Neal A. Schorr.)

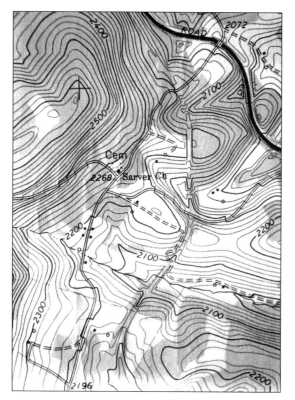

While the Susquehanna River Bridge piers remained in clear view, the remainder of the South Penn right-of-way gradually disappeared into the woods. Much of the route can be found in close proximity to the existing Pennsylvania Turnpike. The graded right-of-way is clearly evidenced by the interrupted contour lines on this U.S. Geological Survey map. To the north of the abandoned railroad is the turnpike as it climbs toward Allegheny Tunnel. (U.S. Geological Survey.)

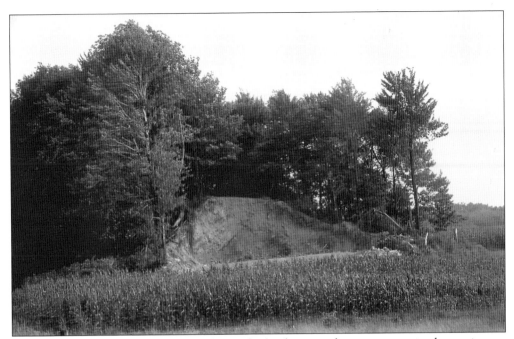

While most of the right-of-way melted into the landscape, a few pieces remained conspicuous. A section of the South Penn roadbed is shown here a century after its abandonment. This fill is located north of Somerset in the middle of a cornfield. The fill has been excavated away, revealing its tapered cross section. (Neal A. Schorr.)

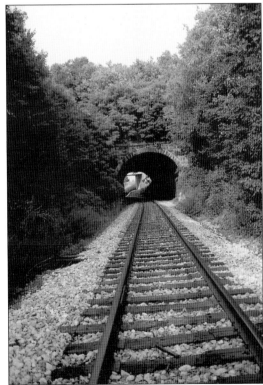

Not far from the excavated fill is the only structure built by the South Penn to have ever been placed in service. This short tunnel north of Somerset carries the unused fill of the South Penn over the tracks of the Baltimore and Ohio Railroad (now CSX) line into Johnstown. Unlike the other tunnels constructed by the South Penn, this one was partially lined with brick. (Neal A. Schorr.)

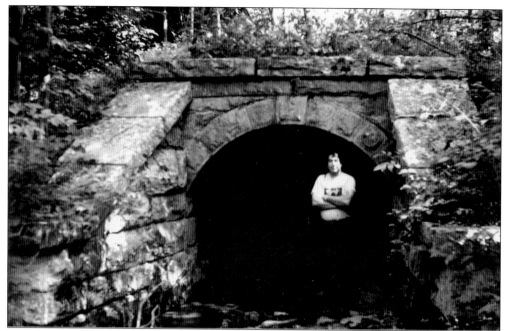

The stone arch culvert shown here was typical of those built by the South Penn. This particular example carries a fill over a stream just south of the present-day turnpike near the Fort Littleton interchange. The size of the culvert is made obvious by the image of one of the authors standing within its opening. (Neal A. Schorr.)

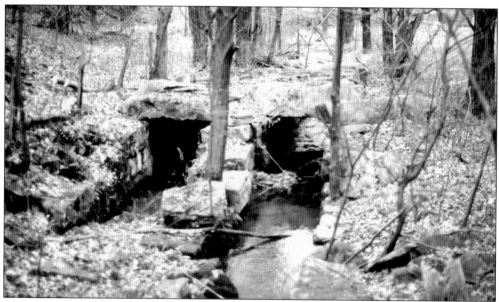

When the order went out to stop all work on the South Penn, the laborers simply walked off the job, leaving many projects unfinished. This partially completed double box culvert is a perfect example. Cut stones ready for placement litter the work site. Out of view to both sides are half-finished fills. Trees have sprouted in the joints between the stones. For a half-century after its abandonment, the South Penn would lie dormant and largely forgotten. (Neal A. Schorr.)

Two

From Railway to Highway

The dawn of the 20th century brought with it a new form of transportation: the automobile. During the first three decades of the century, it was gradually improved and refined, becoming the primary means of transportation within the city. As automotive technology advanced, so did the roads upon which automobiles traveled. During the 1920s, express highways began to be constructed, primarily in and around New York City. Unlike most roads of that era, these new roads featured four lanes, infrequent intersections or grade-separated interchanges, and gentle curves and grades. Often, the opposing sets of lanes were divided by a small curb or grass median. The first such highway was the Bronx River Parkway, opened in 1925.

These developments did not go unnoticed in the commonwealth of Pennsylvania. Here, the Appalachian Mountains were a considerable challenge to motorists and truckers. These difficulties prompted both William Sutherland of the Pennsylvania Motor Truck Association and Victor Lecoq of the state planning commission to come up with the idea of using the old South Penn tunnels and roadbed as the basis for a new toll highway. While the truth may never be known, the most widely accepted story is that Sutherland and Lecoq presented the idea half in jest to state legislator Cliff Patterson in early 1935. In a discussion over a late dinner following an evening session of the state legislature, Patterson bought the idea, much to their surprise.

On April 23, 1935, Patterson introduced a resolution calling for the formation of a commission to study the idea. The resolution passed, and the Works Progress Administration was persuaded to put up $35,000 to investigate the idea. The completed study concluded that the concept was entirely feasible from the engineering standpoint, and arrived at an estimate of $60 to $70 million to build the highway.

Based on these findings, Patterson introduced Bill 211 authorizing the creation of the Pennsylvania Turnpike Commission and the construction of the toll road. The bill passed the state legislature and, on May 21, 1937, was signed into law by Gov. George Earle. Walter A. Jones of Pittsburgh was named as commission chairman.

Unfortunately, the legislation failed to provide funding for the project. The new commission attempted to float bonds to finance the highway. Given the financial realities of the Depression as well as investors' fears that no one would use a toll road in the middle of nowhere, the effort failed, and the bond offering was withdrawn.

Walter A. Jones, being well connected in Washington, was able to interest Pres. Franklin Roosevelt in the project. Recognizing its potential military value in time of war, he lent his support to the project. Through the Reconstruction Finance Corporation and the Public Works Administration, Roosevelt helped secure the funds necessary to fund the construction of the nation's first long-distance superhighway. Vanderbilt's half-finished tunnels would at last see the light of day, though in a manner that he could never have imagined.

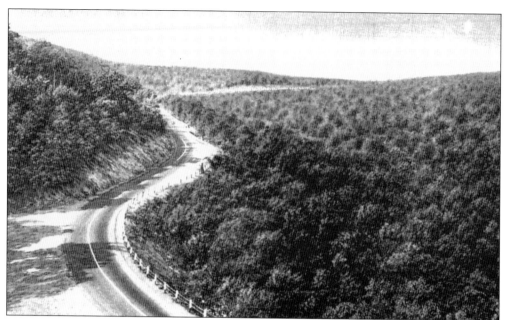

U.S. Route 30, known as the Lincoln Highway, typified what motorists faced when attempting to drive across Pennsylvania in the 1930s. With its steep grades and twisting alignment, it took many hours to traverse the commonwealth. If one had the misfortune of getting caught behind a truck in the mountains, the drive was even worse. The somewhat longer U.S. Route 22 (the William Penn Highway) to the north was only marginally better.

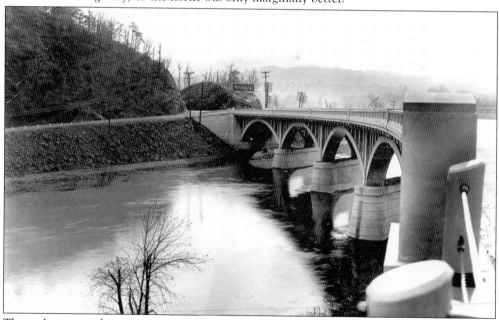

The only gap in the mountains for 50 miles north or south of Bedford was created by the Raystown branch of the Juniata River. Known as the Bedford Narrows, it allowed U.S. Route 30 to pass through, rather than over, the ridge. This graceful five-span curved concrete arch bridge was constructed in 1934, when this section of Route 30 was improved during the Great Depression. The view shown here is looking northeast.

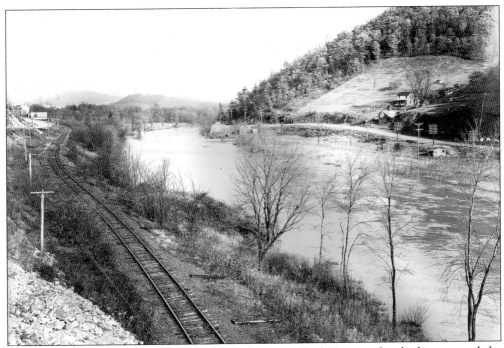

This is a view from the same vantage point in the Bedford Narrows, but looking toward the west. From left to right may be seen U.S. Route 30, a branch of the Pennsylvania Railroad serving the town of Everett, the Raystown branch of the Juniata River, a local road, and Evitts Mountain. This series of photographs clearly illustrates the barriers faced by any highway crossing the commonwealth of Pennsylvania.

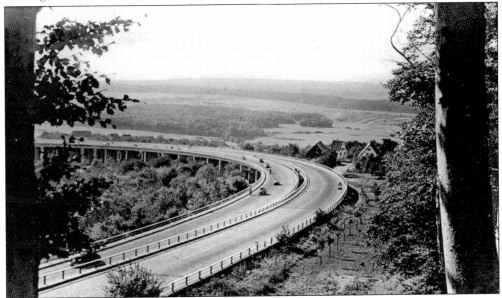

In the 1930s, Germany embarked upon an ambitious program to construct express highways, known as autobahns, across that country. While these were obviously part of Adolf Hitler's preparation for war, their advanced design was part of the inspiration for those seeking to construct a modern highway across the mountains of Pennsylvania.

Connecticut's Merritt Parkway also served to inspire the engineers who designed the Pennsylvania Turnpike. It represented the state of the art in highway engineering when it opened in 1938. The turnpike would build on the success of the Merritt Parkway by advancing the standards used in the design of express highways, such as wide, stabilized shoulders, medians of consistent width, and improved interchange geometry. (Library of Congress.)

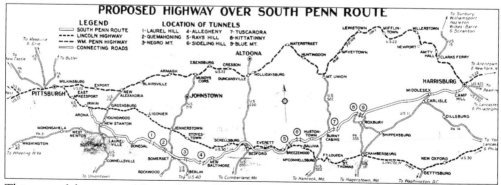

This map of the proposed Pennsylvania Turnpike was published in 1937. It shows the location of the nine South Penn tunnels and the relationship with both the Lincoln and William Penn Highways.

As the commission began its work, crews were sent out to locate and make an initial assessment of the abandoned Vanderbilt tunnels. Here, measurements are being taken of Tuscarora Mountain Tunnel in 1937.

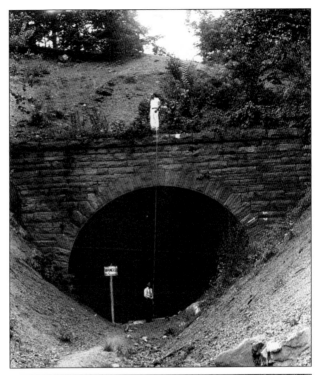

In the half-century between the abandonment of the South Penn and the initial surveys for the turnpike, the partially bored railroad tunnels filled with water, and the approaches slowly became obliterated by rockslides and vegetation. In order to assess the condition of the tunnels, the commission awarded a contract in September 1937 to drain the tunnels. Shown here is the east portal of Blue Mountain Tunnel with the dewatering pipe in place.

Somewhat further along in the process, additional equipment was brought in to assist with the dewatering process. This is Tuscarora Mountain Tunnel. At this stage, the work was conducted for the turnpike commission by the Pennsylvania Department of Highways.

After the tunnels were dewatered, crews moved in to clear rockslides and vegetation from the portals. In this photograph, taken at the western end of Rays Hill Tunnel on October 29, 1937, a steam shovel is shown excavating the face of the hillside in order to gain access to the tunnel.

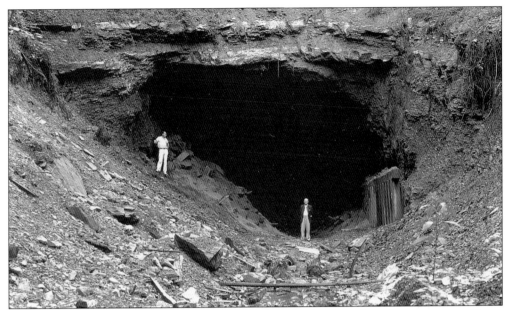

Once the tunnels were drained of water and the portals were cleared, crews were able to evaluate the condition of the tunnels, as shown in this photograph taken on August 11, 1938, at the eastern portal of Rays Hill. These surveys determined that, of the seven tunnel sites that would be used by the turnpike, all except for Allegheny Tunnel were in good enough condition to be converted to vehicular use. Cribbing placed by Vanderbilt's contractors may be seen toward the lower right.

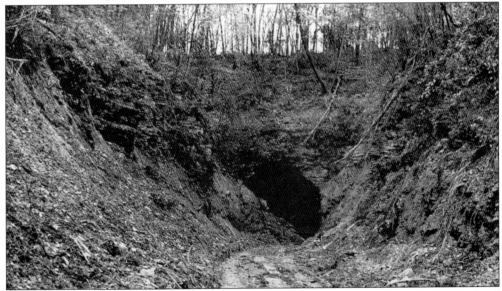

There were to be at least nine tunnels on the South Penn. After the commission completed its initial surveys, it elected to bypass two of them, Quemahoning and Negro Mountain, with deep rock cuts. This is the cavelike Negro Mountain tunnel after its entrance was cleared of debris and vegetation. Although Quemahoning was eventually completed by the Pittsburgh, Westmoreland, and Somerset Railroad in the early 20th century, it too was abandoned after just a few years of use.

Prior to the start of construction, the commission dispatched photographers to document much of the right-of-way. Shown here is a view of the pastoral Pennsylvania countryside through which the turnpike would soon pass. It would not be long before this quiet landscape would be disturbed by the sounds of heavy equipment grading the right-of-way for the nation's first long-distance superhighway.

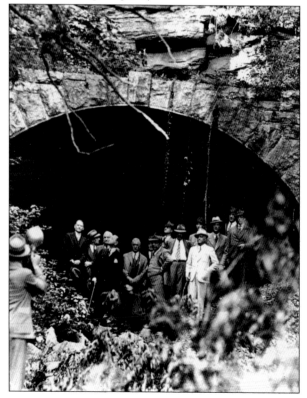

Not long before the start of construction, the members of the turnpike commission toured the route of the planned highway. Here they inspect the eastern portal of Blue Mountain Tunnel. With the financing for the project secured at last, the green light was given to begin construction.

Three

BUILDING THE PENNSYLVANIA TURNPIKE

With funding finally in place, work could at last begin on the new highway. The schedule for completing the turnpike was a tight one indeed, initially calling for the work to be finished by May 1, 1940. The first contract was awarded on October 26, 1938, with groundbreaking occurring the very next day.

Contracts were rapidly awarded for various phases of the work. These included the completion of the old Vanderbilt tunnels, the grading of the right-of-way, the construction of bridges, and the paving of 160 miles of four-lane concrete highway. By the summer of 1939, work was well under way.

The turnpike adhered to the highest engineering standards of the day. It would consist of two 12-foot-wide lanes in each direction. The eastbound and westbound lanes were separated by a 10-foot grass median, a generous width for the time. Stabilized 10-foot shoulders were provided along both the sides of the road. All intersecting roads passed over or under the turnpike, thereby eliminating at-grade intersections. Access was only through one of 11 interchanges.

Besides "holing through" the half-finished railroad tunnels, the commission also widened them to accommodate two lanes of traffic. Powerful fans at each portal provided ventilation, and lighting was by means of mercury-vapor lamps, the most brilliant available at the time.

Furthermore, the alignment of the highway minimized the impact of the mountainous territory traversed by the turnpike. The maximum grade was only 3 percent, and the majority of the highway was built on tangent. By comparison, U.S. Routes 22 and 30 twisted and turned up grades of 9 percent or more. Where possible, the turnpike was built to maximize exposure to the winter sun to help melt snow.

A half-century earlier, the South Penn depended upon picks, shovels, and black powder to bore tunnels and cut the right-of-way through the mountains of southern Pennsylvania. The turnpike commission was able to avail itself of contemporary construction techniques. Powerful bulldozers and scrapers speeded the grading process. When paving operations were slowed by inclement weather in early 1940, paving crews were able to make up for lost time using modern paving and finishing machines. In fact, as the new highway neared completion, they were often able to lay several miles of pavement a day.

Despite the best efforts of the turnpike commission, work was far from complete by the original deadline of May 1, 1940. Several more completion dates came and went over the summer, and plans for formal opening ceremonies were set aside. Finally, as the end of September closed in, the commission announced that the new highway would open just after midnight on October 1, 1940. As word spread that the new superhighway would soon open, motorists flocked to the interchanges, where they waited for the road to be thrown open to traffic. Hoping to be among the first to travel on the new Pennsylvania Turnpike, they were about to see a road the likes of which had never before existed.

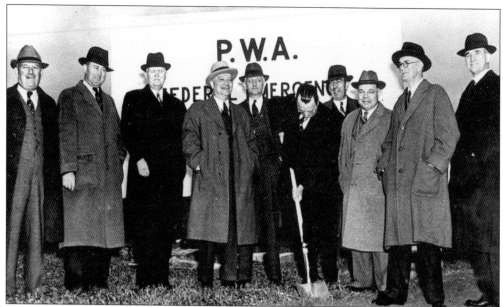

Groundbreaking for the turnpike took place in Cumberland County near Carlisle on October 27, 1938. Walter Jones, the first commission chairman, turned the first shovel of earth. Shown here are, from left to right, two unidentified men, Frank Bebout (commissioner), John D. Faller (attorney), Douglas Andrews (PWA engineer), Walter Jones, Samuel W. Marshall (chief engineer), Edward N. Jones (commissioner), Charles Carpenter (commissioner), and an unidentified man.

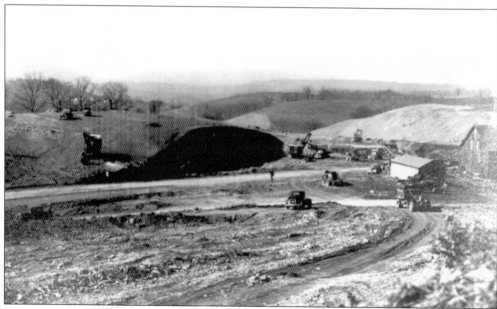

The turnpike commission faced a tight schedule for completing the highway. Following groundbreaking, contracts were quickly awarded to get the work under way. Once the needed property was acquired, the first step was to grade the right-of-way. Because the turnpike would pass through mountainous territory, considerable earthwork was required. The scope of this work was best exemplified by that conducted near Clear Ridge Cut, shown above, just east of Everett.

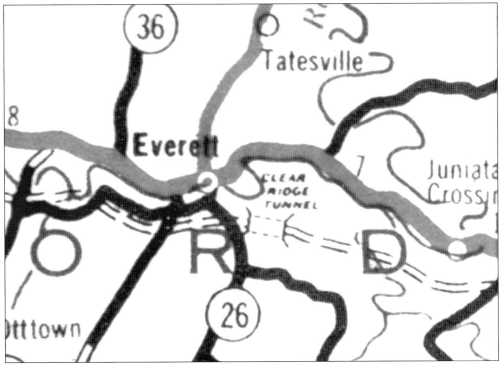

The original plans for Clear Ridge Cut called for the construction of a tunnel, as evidenced in this 1939 highway map. At the last minute, commission engineers decided instead to excavate a cut through the mountain. At 153 feet deep, it would be the deepest cut ever constructed in the eastern United States. As a result, the tunnel notation was deleted from the 1940 edition of the map.

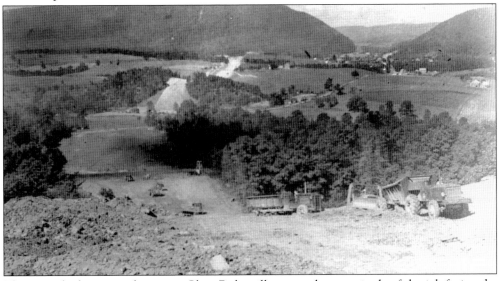

This view, looking west from atop Clear Ridge, illustrates the magnitude of the job facing the contractors. Just to the west of the cut, the turnpike spanned a broad valley by means of an enormous fill. It then passed through a series of smaller cuts and fills just south of Everett before finally passing through Aliquippa Gap in the distance.

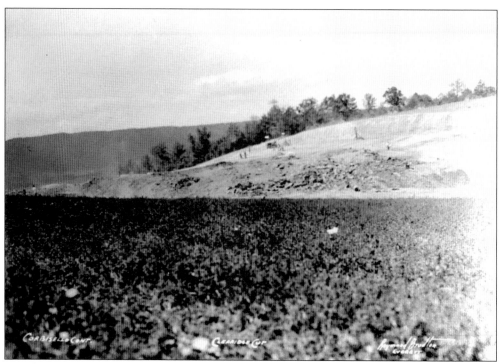

Initial work began on top of the ridge. At this point, bulldozers and scrapers could remove the overburden.

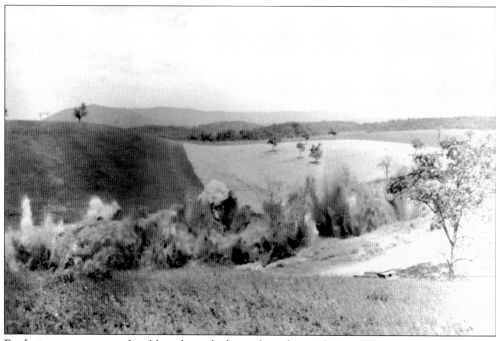

Explosives were required to blast through the rock as the work progressed.

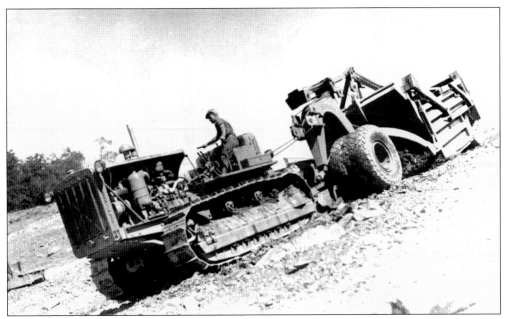

A bulldozer is shown pulling a scraper while excavating Clear Ridge Cut. Modern equipment such as this speeded the work.

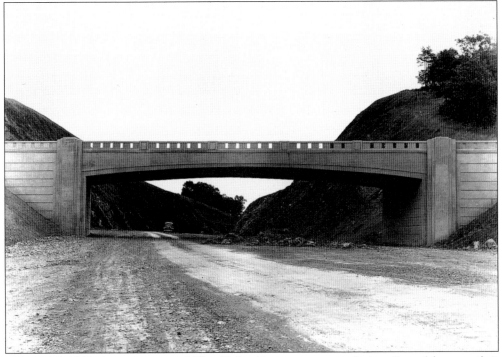

By June 25, 1940, the excavation of Clear Ridge Cut was near completion. One of the turnpike's classic concrete arch bridges frames the western end of the cut. The tremendous depth of the excavation is apparent.

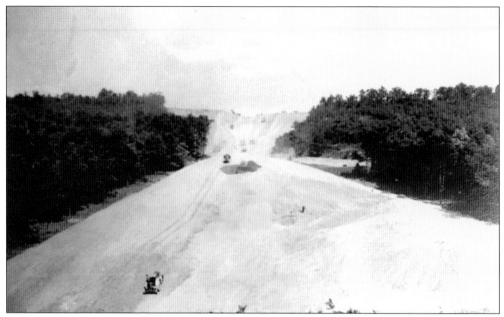

As the work progressed, rock from within the cut was moved to the broad valley just west of the ridge. The excavated material was gradually built up to create the fill that would span the valley. It was compacted layer by layer, thereby allowing the top of the fill and the new highway to reach the floor of the adjacent cut.

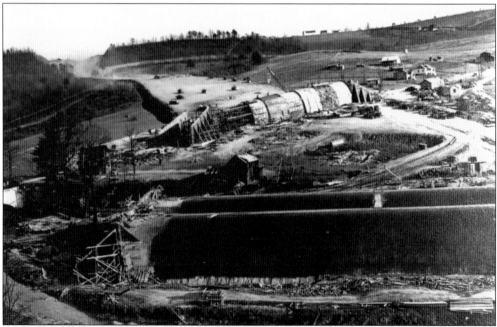

Streams and local roadways were located at the bottoms of the valleys. They passed under the fill by means of enormous concrete culverts, which were constructed before the fills were built up with excavated rock. The double-barreled culvert in the foreground carries a stream, while the one in the center accommodates Route 26. Clear Ridge Cut takes shape in the summit of the ridge to the east.

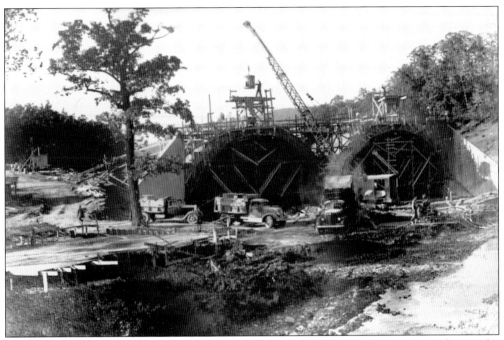

In order to construct the concrete culverts, parabolic wooden forms were erected over the stream. Next, steel reinforcing bars were placed. Concrete was then poured, often lowered to the workers in buckets suspended from cranes, as in the above photograph. The culvert was then waterproofed and, finally, backfilled with rock.

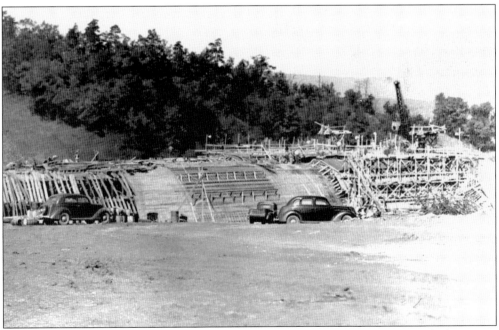

Many man-hours were required to build the complex (but temporary) forms. With the nation still very much feeling the effects of the Great Depression, such labor-intensive work provided jobs for thousands of laborers.

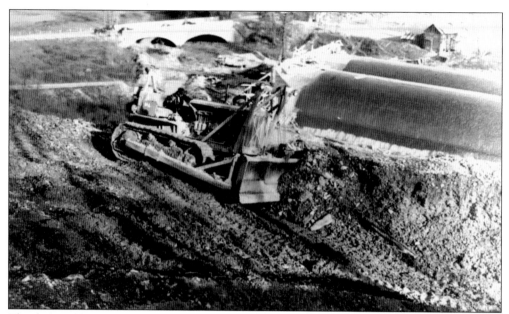

The dark tarlike waterproofing has already been applied to the double-barreled culverts to the right. Toward the center of the photograph, a bulldozer has begun to backfill the new structures. The two-span concrete arch bridge is carrying Route 26 to the south, just before it passes through its own culvert under the fill.

This photograph, taken many years later, is a view of the completed concrete culvert. The structure permitted Route 26 to pass under the fill. Because of its immense size and parabolic shape, it was sometimes compared to a cathedral. (Mitchell E. Dakelman.)

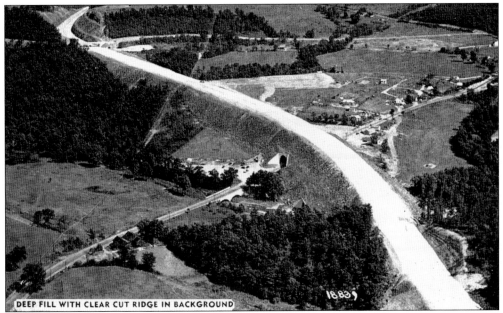

DEEP FILL WITH CLEAR CUT RIDGE IN BACKGROUND

This postcard view features an aerial photograph of the completed fill. Clear Ridge Cut is at the top left of the image. Route 26 can be seen cutting diagonally across the photograph, passing over the two-span concrete arch bridge seen on page 36, and finally burrowing under the turnpike by means of the cathedral-like parabolic culvert. Note the postcard's erroneous reference to "Clear Cut Ridge."

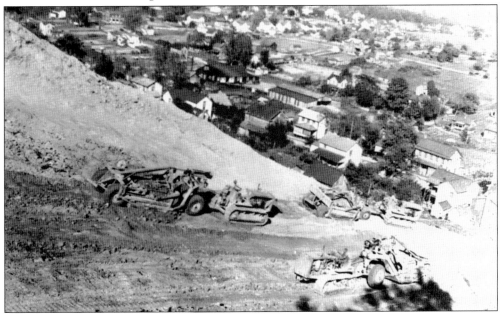

Earlston was a small town just south of Everett and west of the massive fill seen in the previous series of photographs. While the turnpike generally avoided towns and cities, the topography of this area limited the routing possibilities. As a result, the turnpike passed through the edge of town by means of several cuts and fills just west of Clear Ridge Cut. Here a bulldozer and scraper excavate a cut at the south end of town.

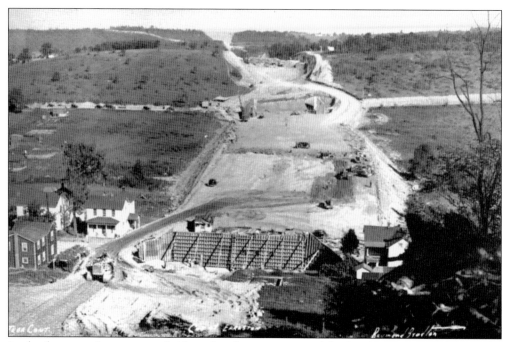

In the foreground, a concrete bridge takes form over one of the local streets in Earlston. Like the immense concrete culverts, these much smaller structures also required the labor-intensive construction of forms. The path of the turnpike is evident as it heads toward Clear Ridge Cut in the distance.

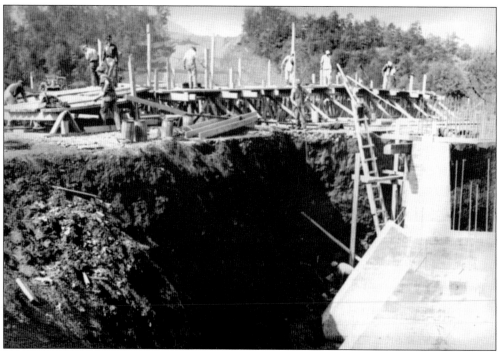

Here, workers construct wooden forms for the small underpass at Earlston sometime in 1939. In the background, the right-of-way has already been cleared of trees and vegetation.

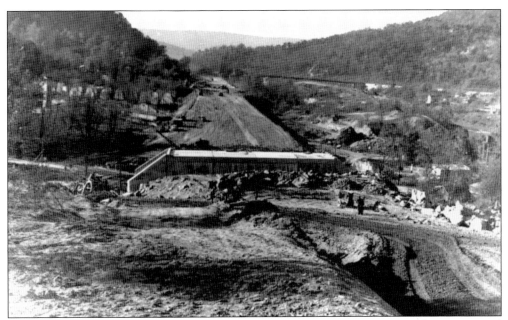

The new bridge is almost complete in this view looking to the west. Essentially an oversized concrete-box culvert, the structure will be backfilled next, prior to the start of paving operations. Aliquippa Gap can be seen in the distance. Aside from the Bedford Narrows to the west, it was the only passageway through the mountains in this area.

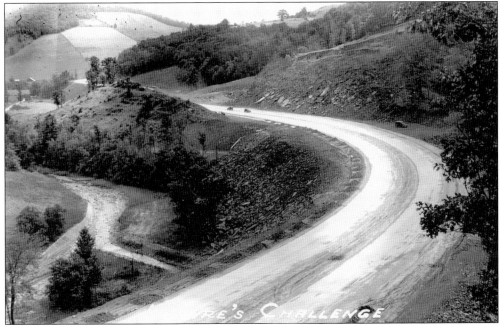

The eastern approach to Allegheny Mountain was another of the most difficult earthwork jobs facing the turnpike commission. Accordingly, the photographer titled his image "Nature's Challenge." It was a seven-mile climb from the town of New Baltimore to Allegheny Mountain Tunnel at the summit. This section of turnpike had the steepest grades and sharpest curves on the new 160-mile express highway.

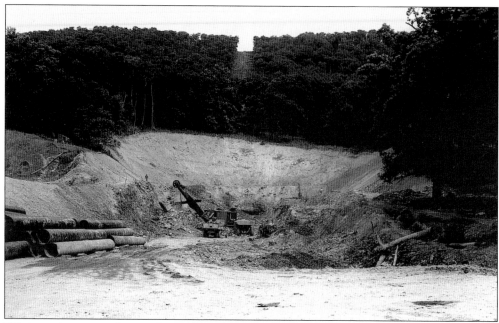

While work continued on grading operations, the commission turned its attention to completing the tunnel bores abandoned by the South Penn a half-century earlier. The western portal of Kittatinny Mountain Tunnel, pictured here on July 27, 1939, was typical. Steam shovels widened the portal area where the fan house would be constructed. Within the mountain, workers finished drilling the partially bored tunnels.

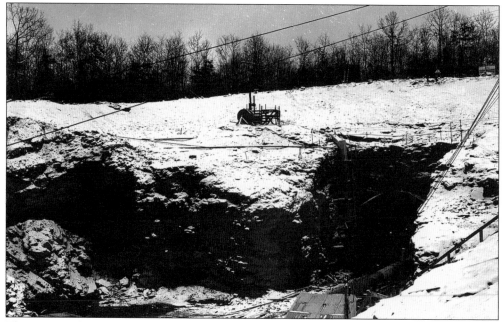

The surveys of 1937 concluded that the condition of Allegheny Tunnel was too poor to allow its use by the turnpike commission. Therefore, a new bore was drilled 85 feet to the south of the tunnel. In this view from the west, the original tunnel can be seen to the left, and the new bore has been started to the right.

After debris and rock were cleared from the tunnel portal, crews entered the partially completed Vanderbilt bores to complete the work that was started in the mid-1880s but was never finished. Taken on August 13, 1939, this photograph of the west portal of Sideling Hill shows the temporary shoring that was installed to stabilize the tunnel.

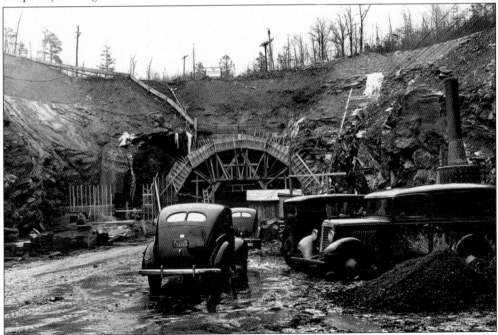

After the tunnels were "holed through," work began on the concrete tunnel liner. The wooden forms used in its construction near the mouth of the tunnel can be seen in this view.

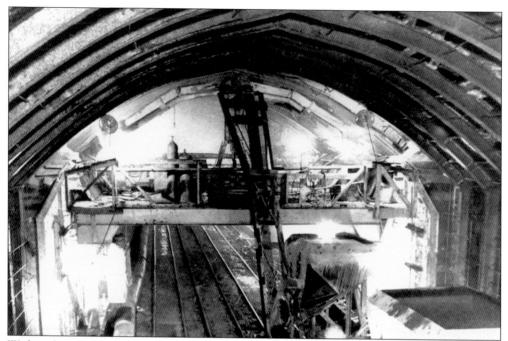

Within the tunnels, steel forms were used to construct the concrete tunnel lining. Rebars used to reinforce the tunnel walls can be seen to the left.

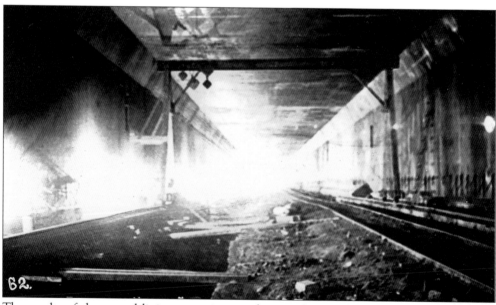

The results of the tunnel-lining operation can be seen here. Temporary tracks are in place to haul construction material into the tunnel. To the left is a trench that will be used for placement of the tunnel's drain, and a suspended concrete slab ceiling has already been placed. The space between the slab and the tunnel's arched roof will be used to force fresh air into the tunnel. The concrete roadway has yet to be poured.

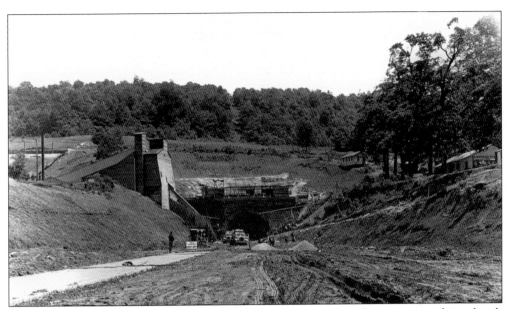

The concrete used in the construction of the tunnel liner and roadway was mixed in a batch plant, seen to the left. A conveyor brought the concrete down to the mouth of the tunnel. By the time this photograph was taken of the western portal of Laurel Hill Tunnel on June 6, 1940, the portal and fan house were nearing completion. Bunkhouses for the construction crews may be seen to the right.

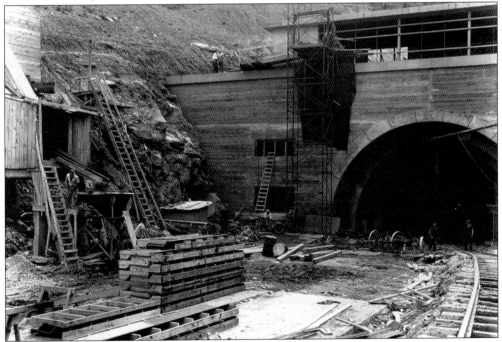

A closeup of the previous view clearly shows the concrete chute emerging from the bottom of the conveyor structure. The fan house is empty, still awaiting the installation of ventilation fans. The tracks used to deliver concrete and other materials to deep within the mountain are about as close as any of the tunnels ever came to handling railroad traffic.

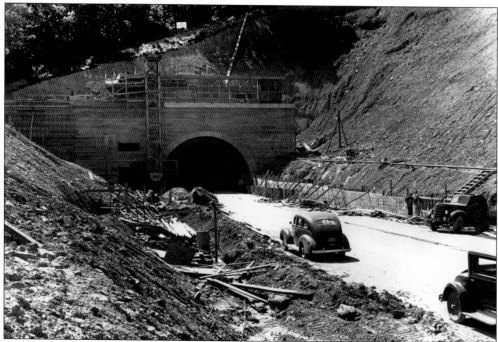

The concrete roadway approaching the eastern portal of Sideling Hill Tunnel was already poured by June 6, 1940. A small concrete retaining wall takes shape to the right of the pavement. The metal frame of the fan house will be fitted with stainless-steel letters spelling out the name of the tunnel and glass panels that will be dramatically backlit at night.

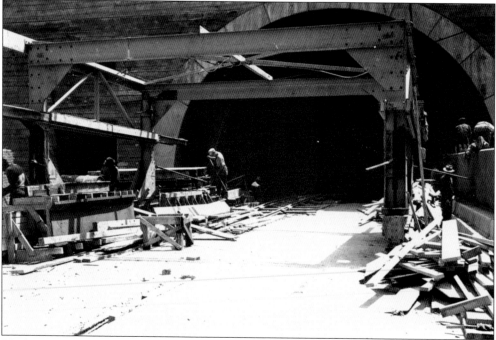

Workmen and a piece of scaffolding used during construction are shown here in the summer of 1940 as a tunnel nears completion.

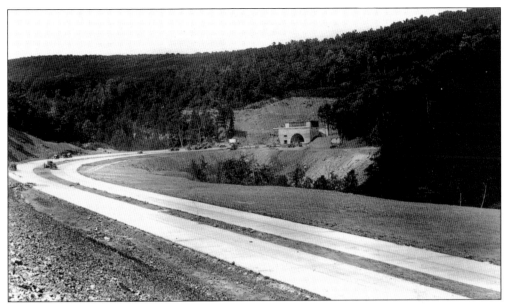

The eastern portal of Allegheny Tunnel was located at the summit of a long and difficult grade up the face of Allegheny Mountain. The grade of the South Penn was located behind the photographer to the left. As it approached the mountain, it cut directly across the path of where the turnpike now lies. It then entered the original (and unused) bore, which is just to the right of the new turnpike tunnel.

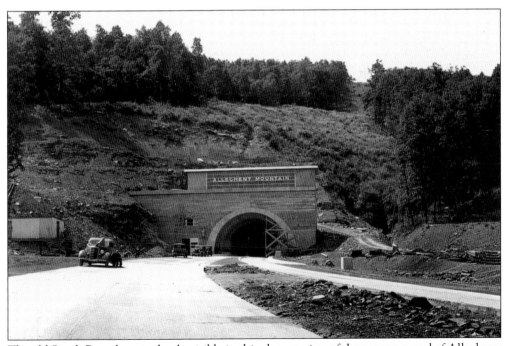

The old South Penn bore is clearly visible in this closeup view of the eastern portal of Allegheny Mountain Tunnel. Twenty-five years later, when plans were afoot to build a new parallel tube here, use of the old bore was again considered and rejected due to the instability of the rock in the tunnel.

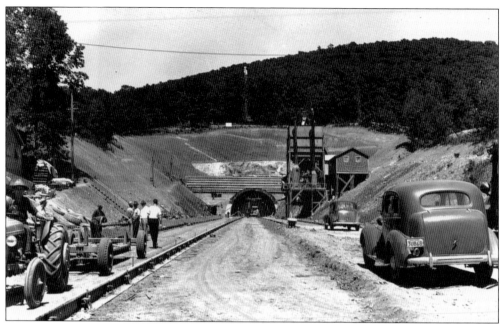

This is a view of the western portal of Rays Hill Tunnel on June 6, 1940. While work is finished up on the fan house and portal, crews have begun to pave the tunnel approach.

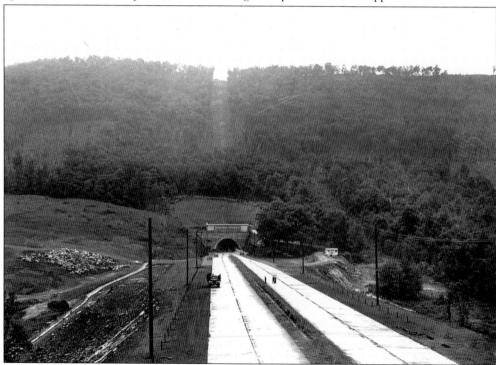

This outstanding view of the western portal of Kittatinny Mountain tunnel shows how the four-lane road narrowed to two lanes as it approached the tunnels. To each side of the superhighway can be seen the partially installed guardrail and wooden poles awaiting installation of the lighting fixtures.

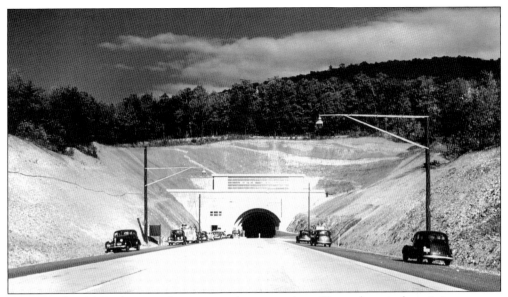

By September 1940, the tunnels were just about complete. Shown here is the pristine western portal of Rays Hill Tunnel. Mercury-vapor light fixtures have now been fitted to the creosoted wooden poles. Note that the roadway at the right has narrowed to a single lane and that two lanes are immediately available at the tunnel exit.

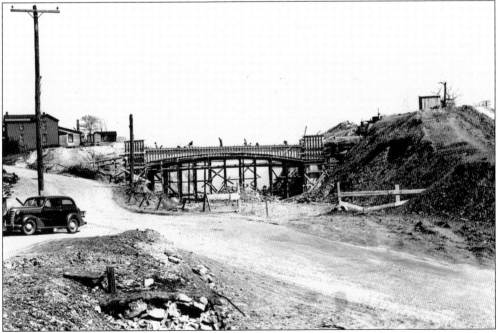

Aside from the seven tunnels, hundreds of bridges had to be constructed. There were three basic types, the concrete rigid-frame arch bridges being the ones most clearly associated with the turnpike. The first stage in the construction of the arch bridges was to erect wooden forms supported by temporary scaffolding. Reinforcing steel bars were then placed within the forms, and finally the concrete was poured. The example shown here is just west of the Donegal interchange.

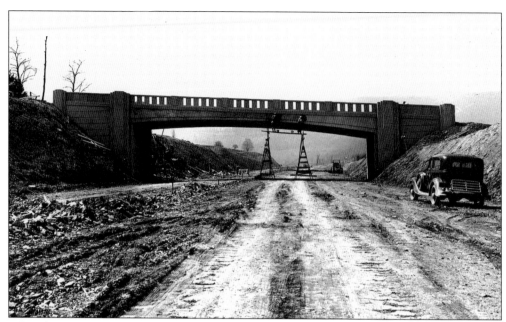

After the arch was poured, the concrete was allowed to set. Next, the scaffolding was removed and the wooden forms were stripped from the bridge. The parapets were then constructed. Finally, the concrete masons performed their final touch-ups on the structure, as shown here on the Findlay Street Bridge in New Baltimore.

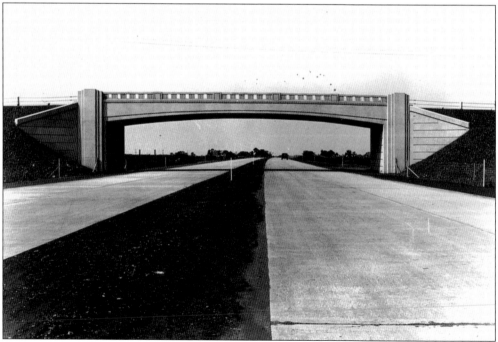

Aside from the seven tunnels, the concrete rigid-frame arch bridges were the turnpike's signature structures. They were clearly the most aesthetic of the three types of overpass structures used on the original section of the turnpike. These bridges came in a number of variations. The bridge pictured here, located near Carlisle, is the most common of the genre.

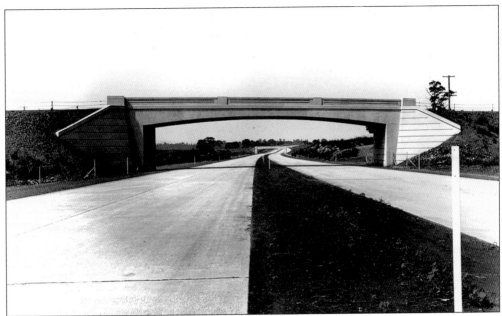

Many subtle variations existed in the masonry work of the turnpike's bridges. For example, this bridge features a solid parapet with longitudinal grooving, rather than the more common open style illustrated previously. The decorative columns at either end of the arch have been omitted, necessitating modification of the wing wall design. This version was less common than the one illustrated at the bottom of page 48.

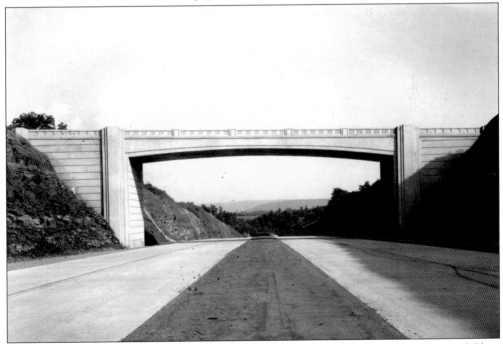

Here is another example of the concrete arch bridges. This one is located just east of Clear Ridge Cut and is notable because it was constructed at a much higher elevation than any of the other concrete arch bridges on the turnpike.

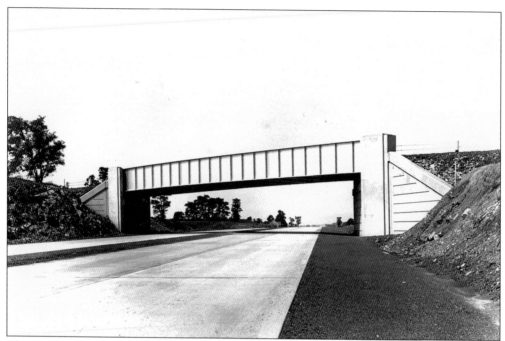

The most utilitarian of the three bridge types was the through-plate girder. While by far the least attractive of the three types, it proved to be the most durable. The bridge pictured here is located near Newville and is typical of the through plate girder bridges. Like the rigid-frame arch bridges, they came with a number of variations in the masonry abutments.

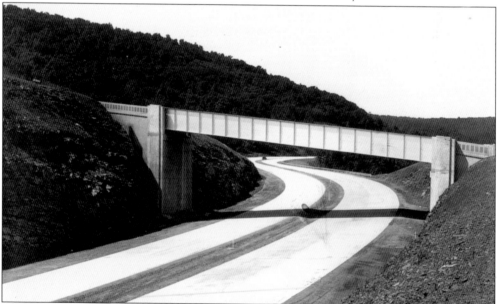

One of the more interesting through-girder bridges was this example, located on the eastern upgrade approach to Allegheny Tunnel. It was notable for its steep grade and the use of wing walls built parallel to the span of the bridge, rather than at an angle. Many years later, the eastbound lanes of the turnpike would be relocated, resulting in the closure of this bridge. It remained standing but unused for a number of years until it was finally removed.

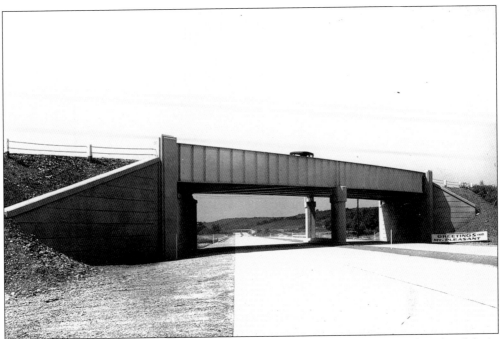

In several instances, local highways crossed over the turnpike on a significant skew (angle). As a result, they did not use any of the three standard overpass designs. The through-girder bridge shown here, near Mount Pleasant, was supported with the use of two columns placed in the median. This is one of two structures built using this general design.

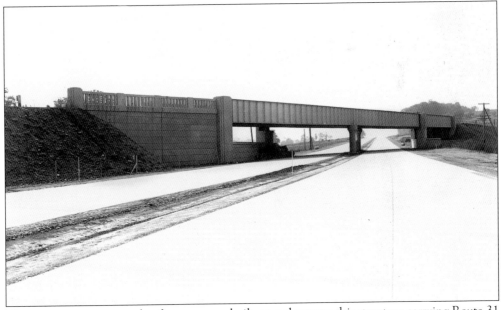

The most extreme example of an overpass built on a skew was this structure carrying Route 31 east of Somerset. The longest overpass on the original turnpike, it required side spans beyond the edge of the shoulder and was the only overpass to have this feature. This extra-long bridge used two additional piers, which were integrated into a wall separating the highway from the area under the side spans. The abutments were necessarily of exceptional length as well.

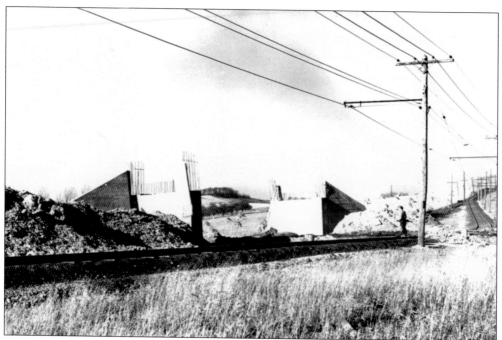

The West Penn Railways interurban line was the only railway that crossed over the original section of the turnpike. The weight of the interurban cars necessitated the use of the steel through-girder bridge design. Shown here on November 10, 1939, are the structure's two abutments under construction. A temporary "shoo-fly" track has been built directly across the path of the turnpike. It will carry rail traffic until the new bridge is finished.

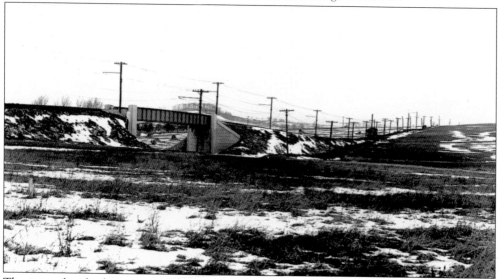

The interurban bridge was completed and in service by the time this photograph was taken on February 23, 1940. A northbound trolley can be seen in the distance. The temporary overhead trolley wire has not yet been removed. This structure was located a few miles east of the New Stanton interchange. After West Penn Railways ceased operations in the early 1950s, the bridge was abandoned but continued to stand unused for many years. It was finally dismantled in 1967.

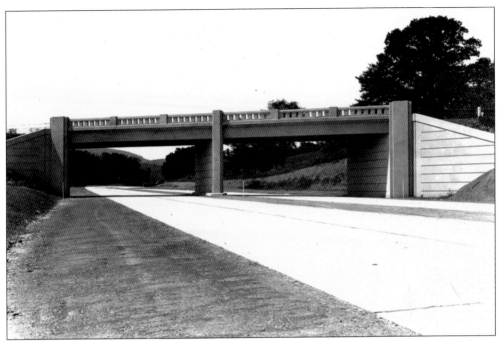

Least common of the three types of bridges on the original turnpike were the concrete T-beam bridges. Built in the early phases of turnpike construction, the bridges used a center pier to allow for shorter bridge spans, thereby lowering the cost of the structures. However, the pier was recognized as a potential hazard, and this style of bridge was not used in the later phases of construction. All were located west of Breezewood.

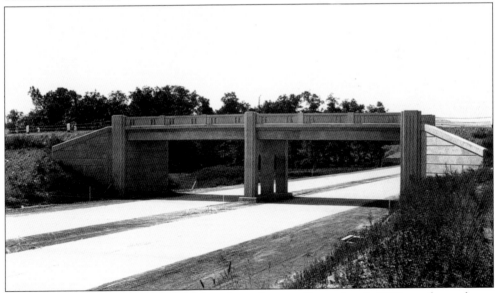

This center-pier, concrete T-beam bridge, shown here on September 6, 1940, was located near the Kegg maintenance facility. Its center pier is constructed of three columns, rather than the somewhat more common solid pier. The center piers were particularly prone to the corrosive effects of deicing salts, thereby shortening the lives of this type of bridge. As a result, all were replaced by the late 1990s.

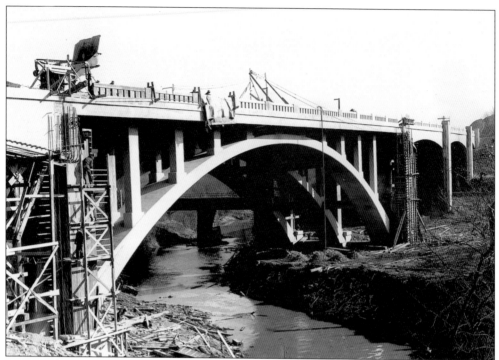

Because the turnpike followed the ridge lines of the Allegheny Mountains rather than the watercourses, there were only a few large bridges on the original section of the turnpike. The westernmost of these was the New Stanton Viaduct, pictured under construction in this photograph. The structure consisted of a central open-spandrel concrete arch with a series of concrete rigid-frame arches on both approaches. It survived until 2002.

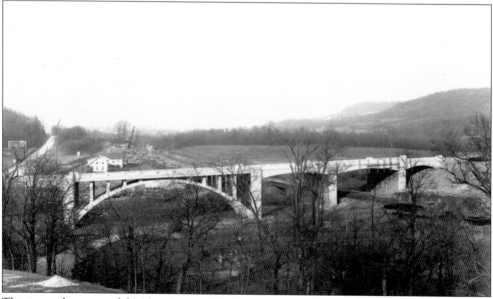

This is another view of the New Stanton Viaduct as it neared completion on April 10, 1940. To the extreme left is U.S. Route 119 as it heads north toward Greensburg. At the right, a branch of the Pennsylvania Railroad passes under the eastern end of the viaduct.

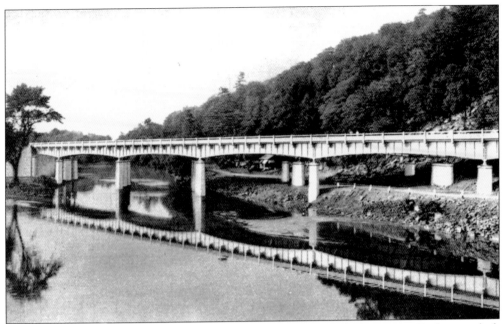

The two other large structures on the turnpike flanked the Bedford Narrows. Both were deck plate-girder bridges. Shown in this postcard view is Dunnings Creek Bridge, on the west side of the Narrows. Considered to be among the most beautiful bridges on the turnpike, it received an engineering award for its design. The steel deck girder Juniata River Bridge was just east of the Bedford Narrows.

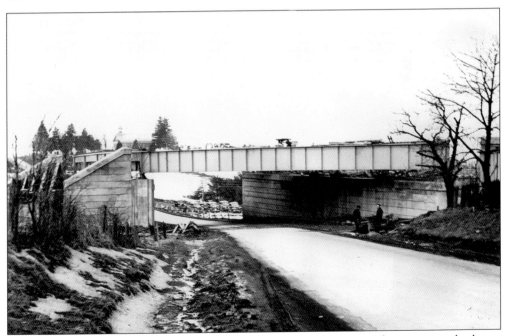

The structure carrying the turnpike over U.S. Route 30 at Breezewood was among the larger bridges on the new highway. In this view, the girders have just been set into place, and the abutments have yet to be backfilled.

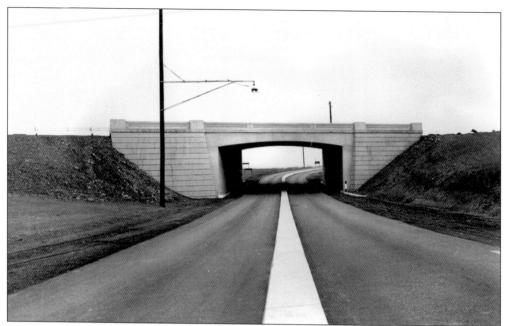

The structures carrying the turnpike over interchanges and intersecting roads were generally shorter than those spanning the turnpike itself. Illustrated here is the bridge carrying the main line of the turnpike over the ramps serving the eastbound lanes of the turnpike at the Breezewood interchange. This view is looking toward the west. Note that the ramps were constructed of asphalt instead of concrete, which was used for the main line of the turnpike.

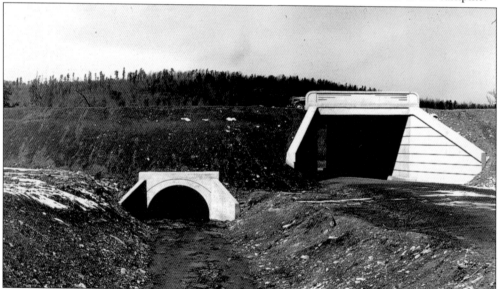

This photograph, taken between Rays and Sideling Hill Tunnels, shows an outstanding example of two common types of structures built by the turnpike commission. To the left is a small concrete arch culvert. To its right is a concrete T-beam bridge, which carries the turnpike over Oregon Road in the Buchanan Forest. It is representative of the numerous small bridges that carried the turnpike over local roads. Prominent is the stylized parapet design unique to the turnpike.

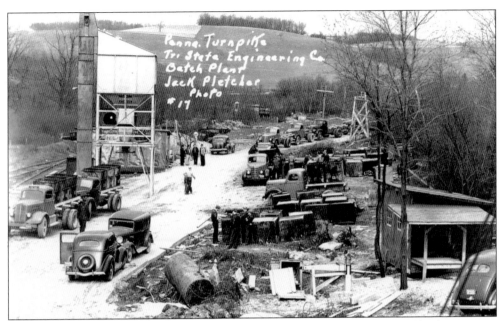

While the commission made rapid progress on the construction of tunnels and bridges, paving operations—and the scheduled opening of the turnpike itself—fell far behind schedule. As a result, crews were forced to work at a rapid pace throughout the summer of 1940 to get the job done. Shown here is one of the concrete batch plants used that summer. The small plants, such as this one, photographed by Jack Pletcher, were used along the project.

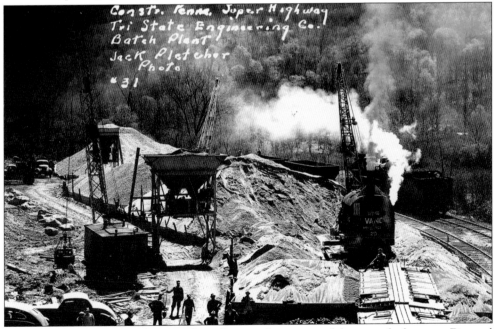

Pletcher concentrated his photographic efforts on the section of the turnpike between Donegal and Somerset. Here is another photograph he took of the same batch plant shown in the previous photograph. Construction materials are being delivered by rail, as evidenced by the freight cars toward the right of the image.

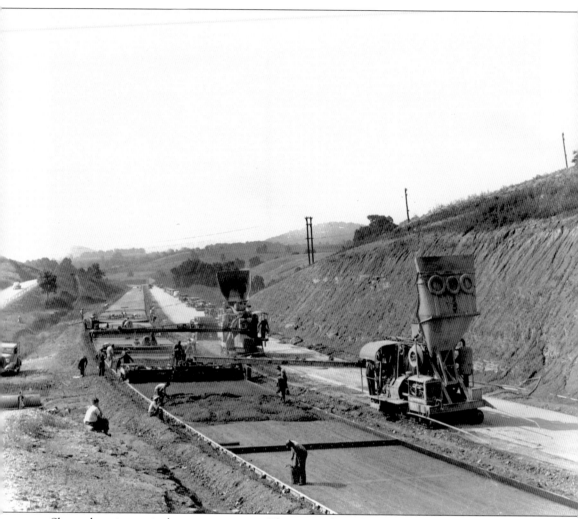

Shown here is a typical paving operation. The materials used in the concrete mix were trucked to the construction site and deposited in collecting bins on the mobile concrete mixers. The bins were then raised to a vertical position, as seen in the photograph, allowing the dry concrete to drop into the mixer and be combined with water. Once it was ready to pour, the concrete was then deposited into a bucket suspended from a boom, moved into position over the section of roadway being constructed, and poured in the vicinity of the paving machine. The concrete was poured directly onto the compacted earth, without benefit of a gravel base. Steel forms were placed at the margins of what would become the concrete roadway. The forms acted as rails, allowing the paving machine to move forward, molding the liquid concrete into the nearly finished roadway. The masons followed behind the paving machine, finishing the surface of the road by hand. Finally, the freshly poured roadway was covered with canvas to retain moisture while curing.

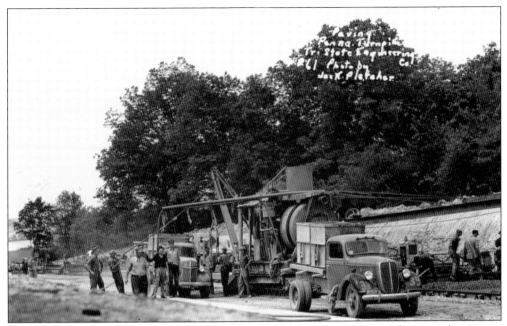

This is another view of one of the cement mixers used in the paving of the turnpike. Just to its right is a paving machine, which spread the concrete between the forms at the edge of the pavement.

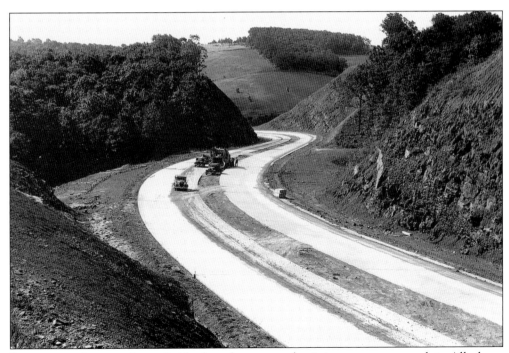

Paving operations are almost finished on the steep and twisting eastern approach to Allegheny Mountain Tunnel.

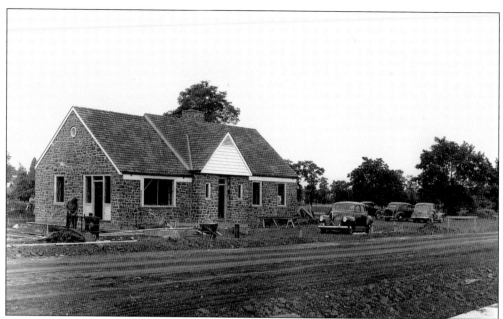

The interchanges on the original section of the turnpike usually served remote, rural areas, and as such, neither gas nor food were readily available at the exits. Therefore, the turnpike commission saw fit to construct service plazas at intervals of approximately 30 miles. New Baltimore, pictured here under construction, was typical of the original service plaza structures. It would last only until 1955, when it was replaced by a new structure near Somerset.

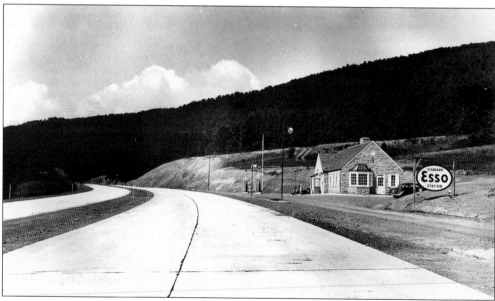

Here is a photograph of the nearly completed Cove Valley service plaza, just east of Sideling Hill Tunnel. As with all of the other service plaza structures, it was built of native fieldstone and was meant to be suggestive of typical Pennsylvania architecture. Over the years, these structures would be either enlarged or replaced by larger service plazas. Cove Valley was in fact replaced by Sideling Hill service plaza in 1968.

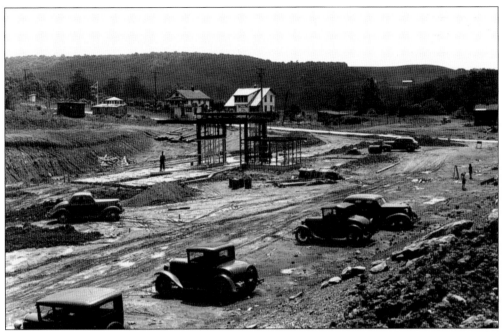

Tollbooths, originally known as "ticket offices," were among the other structures built along the new highway. The two-lane New Stanton toll plaza was typical of the small toll facilities built at the intermediate interchanges. The framework for the tollbooths may be seen in this view looking toward the east. U.S. Route 119 is in the background.

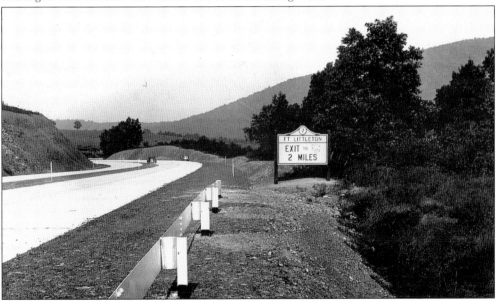

The Pennsylvania Turnpike was a showcase for the latest innovations in highway engineering in 1940. Rather than using a guardrail built of steel cable mounted on wooden posts, which was typical of that era, the guardrail used on the turnpike was constructed of continuous steel panels mounted on I-beams. Large exit signs with oversized lettering were used well in advance of the exits. Some decorative flair was also added in the form of the artistically designed exit number atop the sign.

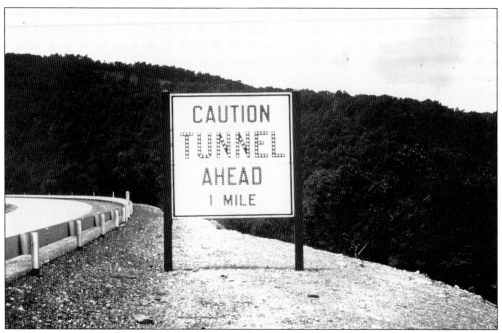

Another sign commonly seen on the turnpike was that giving motorists notice that a tunnel was just ahead. Demountable lettering using cat's-eye reflectors was used to increase nighttime visibility. Also note how the face of the guardrail has been blocked out from the posts to prevent cars from snagging on the posts in the event of an accident. (George L. Frost.)

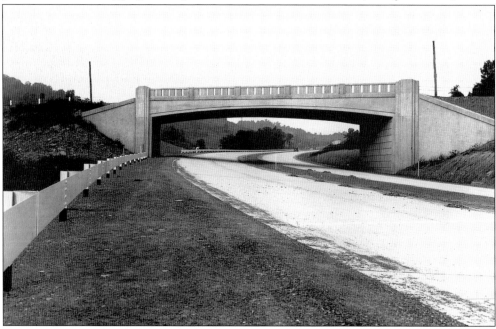

As 1940 wore on, the almost finished highway began to take on its final form. This scene, just west of the New Stanton interchange, is typical. All of the classic turnpike elements, such as the rigid-frame concrete arch bridge, skirt-type guardrails, stabilized shoulders, and median-mounted cat's-eye reflectors, are present.

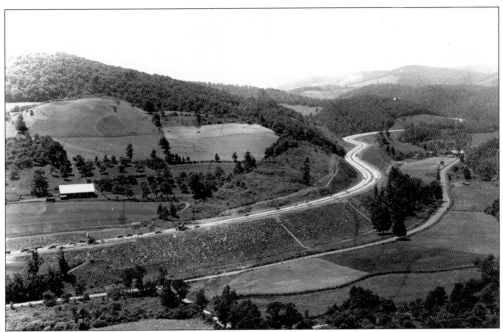

The difficult eastern approach to the tunnel at the summit of Allegheny Mountain nears completion in this photograph. The 2 percent uphill grade of the South Penn was built to the south of the new highway. The turnpike engineers designed a shorter route, albeit one with sharper curves and grades of up to 3 percent.

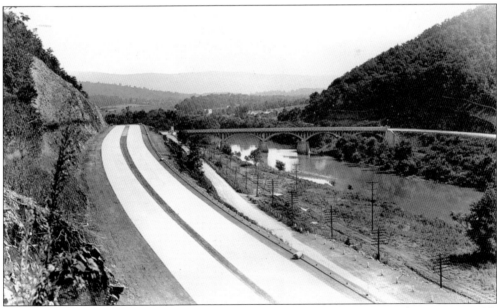

To the east, the turnpike squeezed through the Bedford Narrows along with U.S. Route 30, a Pennsylvania Railroad branch line, the Raystown branch of the Juniata River, and a local road. This was accomplished by blasting away the face of Evitts Mountain. The curved bridge carrying U.S. Route 30 can be seen in the background. Compare this photograph to the ones on the bottom of page 22 and the top of page 23.

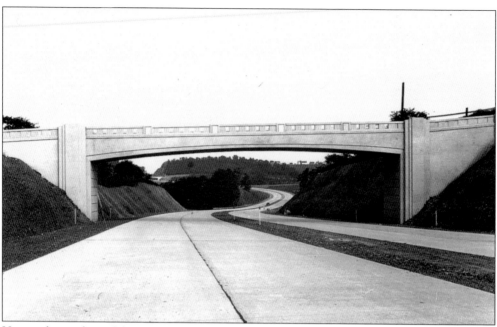

Here is the product of the construction illustrated on pages 30 through 39. The almost finished highway curves gracefully south of Everett by means of a number of small cuts near Earlston. Hidden by the trees in the center of the photograph is the massive fill just west of Clear Ridge Cut, which can be seen in the distance. This was the biggest earthmoving job on the project.

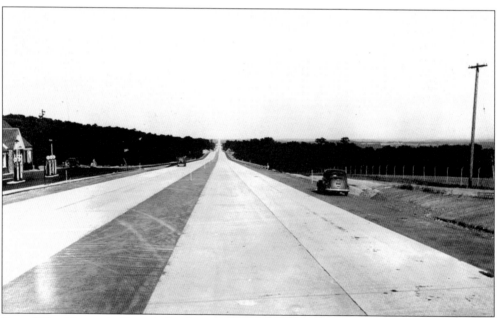

East of Blue Mountain Tunnel, the character of the turnpike changed dramatically. For 13 miles between the Blue Mountain service plaza and the town of Newville, the turnpike was built as an arrow-straight tangent over the rolling Pennsylvania countryside. This section of the highway came to be known as the "straightaway." A dead-straight stretch of road of this length was virtually unheard of in a state as mountainous as Pennsylvania.

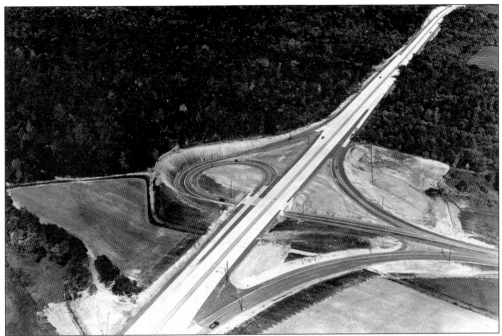

Along with the main line of the turnpike, 12 interchanges also took form. This aerial view of Blue Mountain interchange shows its "trumpet" design. With the exception of New Stanton, Carlisle, and Middlesex, all of the interchanges shared this layout. The trumpet design was extremely well suited for use on a toll highway because it allowed all of the ramps to come together at the tollbooths. At the same time, motorists were never forced into the path of oncoming traffic.

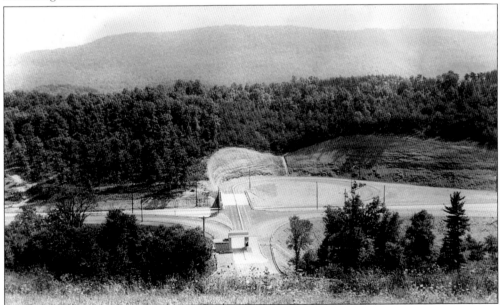

This photograph of the more compressed Fort Littleton interchange illustrates how the tollbooth was placed at the junction of the ramps. Just out of view at the bottom was the intersection between the interchange and U.S. Route 522.

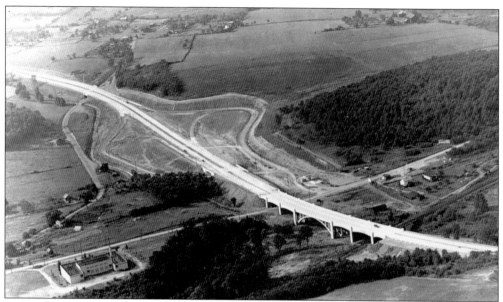

The New Stanton interchange was the most significant deviation from the standard trumpet design. As seen from the air, it consisted of looping ramps on both sides of the highway and was the only interchange of its type ever constructed on the turnpike. Its design forced motorists to cut across the path of oncoming vehicles. The problem was corrected when the entire interchange was relocated to the north and west in 1962.

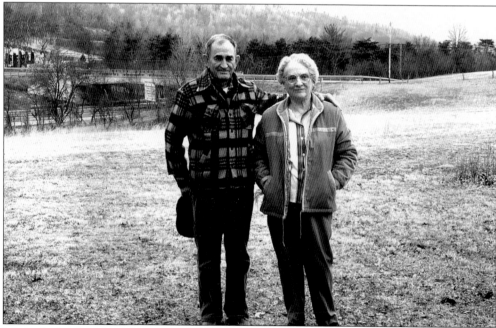

It was the hard work of thousands of men who labored on the project for nearly two years that made the turnpike a reality. Among them was Charles Martz, who was born and raised near Hustontown. After the turnpike's opening, he went to work for the turnpike commission. He is shown here with his wife, Ruth, at their summer cottage near the Fort Littleton exit in March 1990. He often referred to the turnpike as the "Old Vanderbilt Railroad."

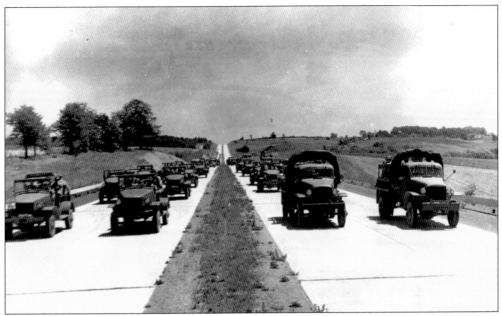

The nearly finished highway was put to a few creative uses even before its official opening. In August 1940 a military convoy traversed the finished sections of the turnpike. Since the turnpike had not yet opened, this photograph was staged so that the vehicles appeared to be using all four lanes of the highway. The motorcade was photographed several times along the journey.

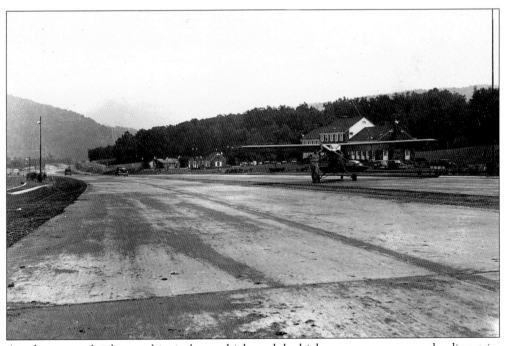

Another unusual sight was this airplane, which used the highway as an emergency landing strip. The aircraft is shown in front of South Midway service plaza on September 15, 1940.

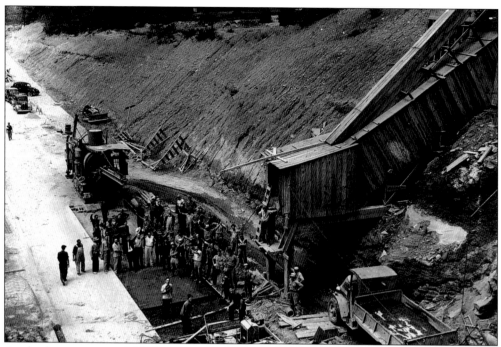

As the long summer of 1940 came to an end, so did paving operations on the turnpike. In August of that year, construction workers posed for turnpike photographer Jean Schwartz, who had perched himself atop of the west portal of Laurel Hill Tunnel to document one of the final paving operations. It would not be long until the turnpike would finally open to traffic.

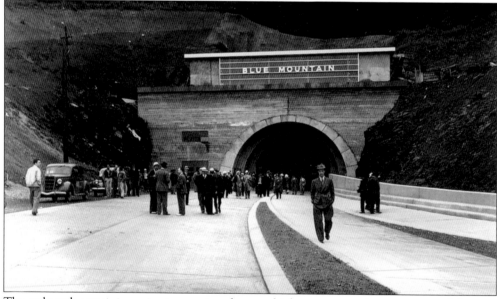

The only task remaining prior to opening the new highway was to give a preview of the new facility to those involved in its creation. Commission chairman Walter A. Jones led a caravan over the length of the entire turnpike on August 26, 1940. It began with a banquet at the Hotel Hershey, 12 miles east of Harrisburg, and ended with an evening of entertainment at the Duquesne Club in Pittsburgh. Here, the group previews the new Blue Mountain Tunnel.

Four

THE WORLD'S
GREATEST HIGHWAY

When the turnpike finally opened on October 1, 1940, motorists were greeted by a 160-mile-long ribbon of pristine white concrete. Unlike any other road that they had ever seen or traveled upon, this one had no speed limits, stoplights, or intersections. Word of the fabulous new highway spread rapidly, attracting drivers from all over the country. The skeptics who predicted that no one would use the new highway were quickly proven wrong. In fact, in its first year of operation, the turnpike carried almost twice as much traffic as originally predicted. Clearly, the Pennsylvania Turnpike was an engineering and transportation triumph.

Unexpectedly, the new highway began to develop a mystique that its creators never foresaw. Fueled in large part by the seven tunnels, the turnpike became not only a means of travel but an attraction as well. The turnpike commission and its service plaza concessionaire, Howard Johnson's, availed themselves of every opportunity to use the romance of the new highway for shameless self-promotion and the generation of new business. The commission issued maps and brochures glorifying the new highway. Postcards, banners, and all manner of turnpike trinkets were placed on sale at the service plazas. Along the way, the slogan "World's Greatest Highway" was created and used over and over on turnpike publications and souvenirs.

Dining became a part of the turnpike experience as well. Some chose to picnic along the new highway, usually at roadside, but occasionally even in the grassy median. Others would stop at one of the service plazas located roughly every 30 miles. As with the tunnels, names such as Cove Valley and Midway quickly became ingrained in the minds of the motoring public.

The commission was also quick to point out other advantages of the new road. A dedicated fleet of maintenance and snow-removal vehicles was always available to keep the road open in the midst of winter snowstorms. The highway was regularly patrolled by the state police. Twenty-four-hour-a-day roadside service was available to the motorist in distress.

Some changes came rapidly to the turnpike. Less than a year after its opening, a 70-mile-per-hour speed limit was posted in the interest of safety. Traffic volumes, which were steadily increasing, saw an abrupt drop with the advent of World War II and the imposition of gasoline rationing. A 35-mile-per-hour wartime speed limit was put into effect. After the war's end, traffic volumes returned to, and then quickly surpassed, their prewar volumes.

Even before the turnpike was opened in 1940, calls went out to extend the new highway in order to span the state. The success of the turnpike would turn those cries into reality shortly after the war. In fact, the Pennsylvania Turnpike spurred the construction of new toll express highways throughout the eastern United States in the postwar period and the Interstate Highway System thereafter.

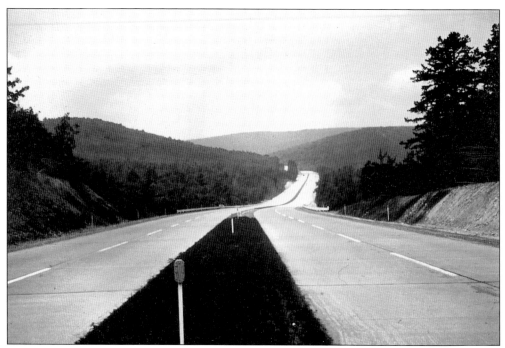

The stretch of highway between Rays and Sideling Hill Tunnels was typical of what greeted motorists traversing the new road. Taken by turnpike patron George L. Frost, this photograph is remarkable for the fact that the original image was created using color film during the turnpike's first year of operation. This is a view looking to the west.

The commission dispatched teams of photographers to document the newly opened highway using Kodachrome color transparency film, an expensive proposition in 1940. Here, the official turnpike photographer captures a view of both the turnpike and his vehicle just west of Tuscarora Mountain Tunnel. The mountain in the distance was variously known as Pyramid Point, Sidney's Knob, and Henry's Knob.

In this view, the photographer has now traveled about a mile or so to the west, parking on one of the wide pull-offs common on the turnpike. The view looks to the east, and Tuscarora Mountain Tunnel is to the right, just beyond the bend in the distance.

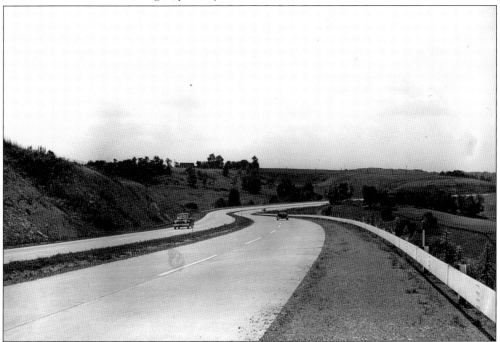

Another view from the turnpike's earliest days shows the famous curves just east of the Fort Littleton interchange. Usually photographed looking to the east, this westward view gives a different perspective to the classic scene illustrated on page 2. (Library of Congress.)

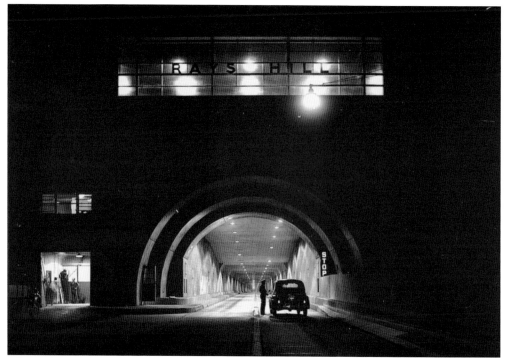

The seven tunnels were the focal point of the new highway. This staged photograph of Rays Hill Tunnel powerfully dramatizes the brand-new facility. It was among the first that would glorify the Pennsylvania Turnpike. (Library of Congress.)

The eastern portal of Rays Hill Tunnel was unique, as it was the only one of the 14 tunnel portals that did not have a fan house. At 3,532 feet in length, Rays Hill was the shortest of the seven turnpike tunnels, and the fans located at the western portal were sufficient to ventilate exhaust fumes from the length of the entire tunnel.

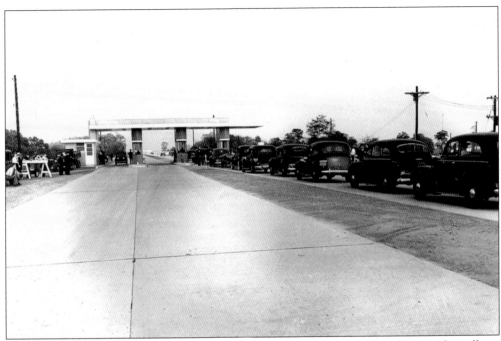

All vehicles entering and exiting the turnpike passed through the tollbooths, or ticket offices, located at each interchange. Illustrated here is a long queue of eastbound traffic exiting the turnpike at Carlisle on the first Sunday of the new highway's operation. The tollbooths were never intended to handle the volume of traffic that actually used the turnpike, and such backups became common until the toll facilities could be expanded.

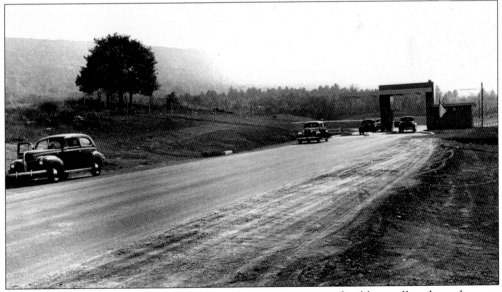

The tollbooths at the intermediate interchanges were considerably smaller than those at Carlisle and Irwin, the two endpoints of the highway. The two-lane Breezewood toll plaza was typical of the small facilities that served rural areas. This interchange serviced U.S. Route 30, located directly behind the photographer. Ramps leading to the turnpike are just beyond the tollbooth. This photograph is believed to have been taken in 1942.

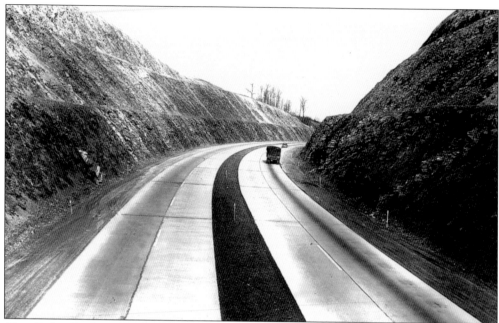

Clear Ridge Cut became one of the new road's best-known landmarks. This photograph, taken from the bridge pictured on the bottom of page 33, is an eastward view of the finished cut. "Benches," which were cut into the hillside, and extra-wide shoulders were used to keep falling rock from reaching the pavement.

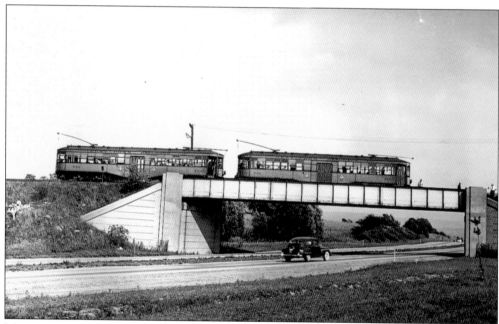

Motorists were occasionally treated to the sight of a West Penn Railways interurban car crossing the turnpike on the overpass illustrated on page 52. On August 10, 1952, the National Railway Historical Society operated a fan trip on the line prior to its abandonment. A photograph stop was staged using two cars posed on the 91-foot-long, skewed through-girder bridge.

Pennsylvania law permitted the right-of-way necessary to construct the turnpike to be acquired by the use of eminent domain. The notable exception was the St. John's Church property at New Baltimore, which contained a cemetery. Because state law did not permit the commission to acquire graveyards by eminent domain, it was forced into negotiations in order to acquire the needed property from the church.

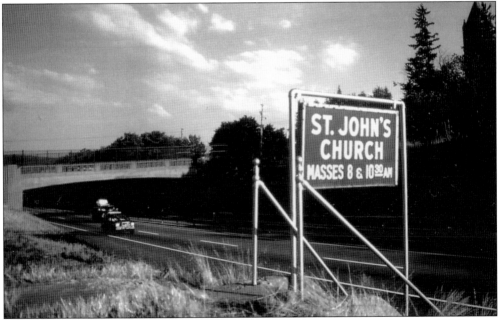

St. John's eventually agreed to the sale of the portion of its property required to build the new superhighway. As part of the agreement, the commission agreed to permit access to the church from the turnpike by means of a pair of stairways serving both the east and westbound lanes. It remains the only location where the commission permits access to private property directly from the turnpike. (Neal A. Schorr.)

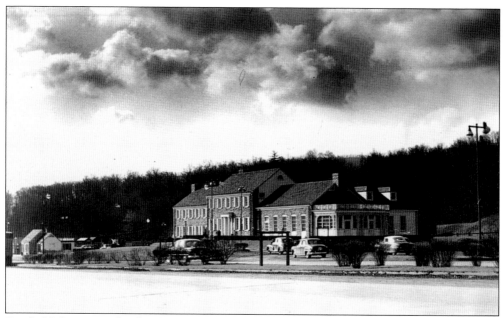

South Midway was the flagship service plaza of the original 160-mile turnpike. So named because it was at the midpoint between Carlisle and Irwin, it was by far the largest of all the service plazas. It was notable for its elegant dining room and trucker's dormitory. It was connected by a tunnel to the smaller North Midway service plaza, located directly across the turnpike. The tunnel allowed westbound motorists to take advantage of South Midway's full-service dining facilities.

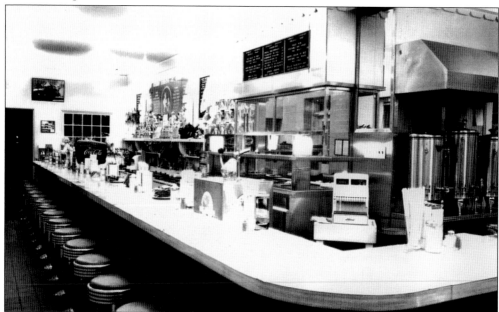

While "the Midway," as it was often referred to, had a large dining room, the other plazas initially had smaller lunch counters, such as this one at Cove Valley. Howard Johnson's was contracted to provide food service, including their famous 28 flavors of ice cream. These small facilities proved to be inadequate and were enlarged shortly after World War II.

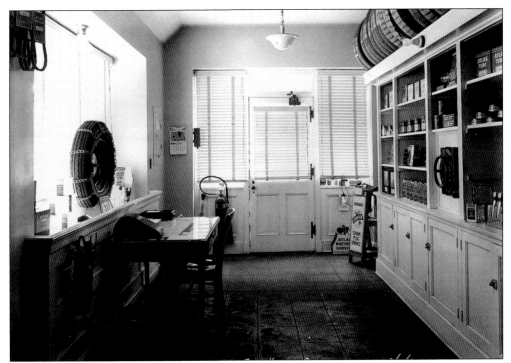

Service stations, which sold gasoline and performed basic repairs, were also located at the service plazas. The small service station office area at Cove Valley was exceptionally neat and tidy for the official turnpike photographer, who took this picture on March 2, 1941. Tires, fan belts, and batteries were all available for purchase. Eastern States Standard Oil (Esso) was the concessionaire. (Brockton Studio.)

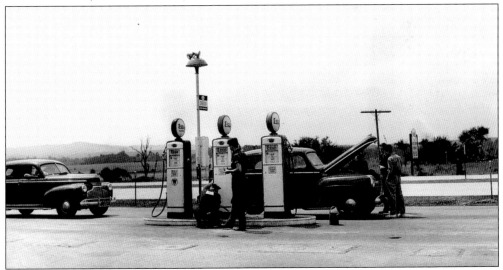

Motorists could purchase gasoline, which was otherwise unavailable in the remote rural areas of central Pennsylvania, at the service plazas. Uniformed attendants pumped fuel, checked oil, and washed windshields. Minor repairs could be performed at the small service stations. Towing and emergency service was provided to motorists unfortunate enough to break down along the turnpike. (Library of Congress.)

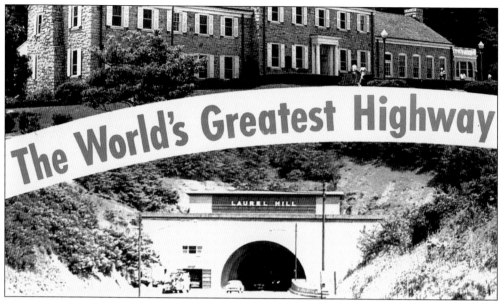

The turnpike commission used other means besides publicity photographs to nurture its image. The boastful moniker "World's Greatest Highway" began to appear on postcards, maps, and other literature produced by the turnpike commission and its vendors throughout the 1940s and 1950s. While the claim began to wear thin over the years, it was undoubtedly the truth when the highway first opened.

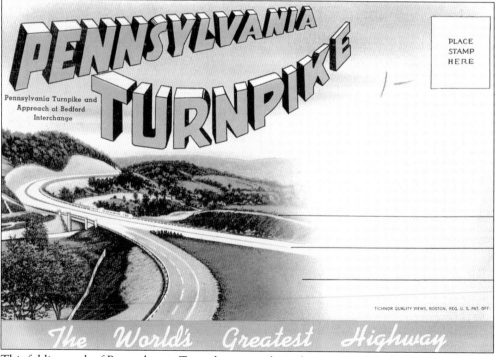

This folding pack of Pennsylvania Turnpike postcards used an image of the highway just east of the Bedford interchange for its cover illustration. The phrase "World's Greatest Highway" was used repeatedly on souvenirs and promotional material during this era.

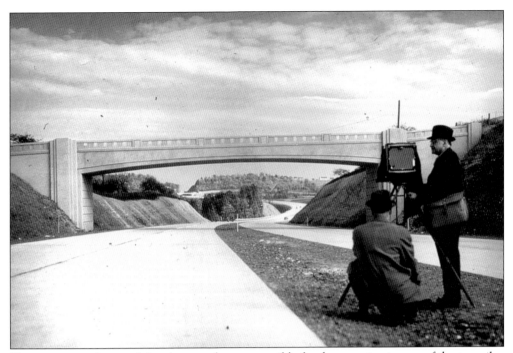

Here is a view of some of the photographers responsible for the stunning images of the turnpike. Their work was used by both the turnpike commission and Howard Johnson's in promotional material and souvenirs. The results of their work at this site may be seen at the top of page 64.

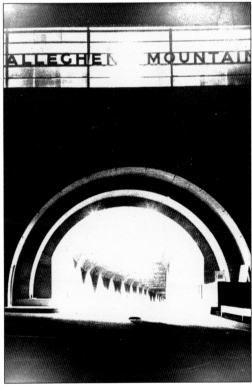

While the slogan "World's Greatest Highway" was an accurate statement in 1940, the turnpike commission was not adverse to a bit of embellishment. In this dramatic promotional photograph of Allegheny Mountain Tunnel, the talents of the photographers have been put to good use in order to exaggerate the intensity of the tunnel lighting. The tunnels were the most notable feature of the new highway, but with the passage of time, they would become its greatest liability.

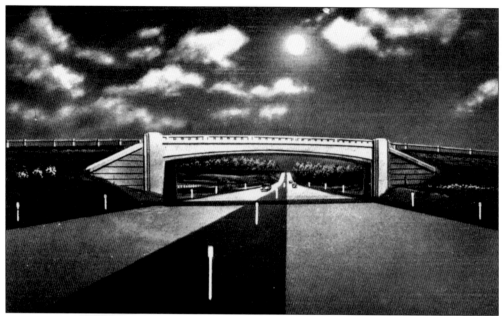

The art of exaggeration was not reserved for publicity photographs. It was also extended to a series of artistically enhanced postcards that portrayed the new highway. Bridges, tunnels, interchanges, and panoramic views were all featured on the postcards, which were available for sale at the service plazas. Among those that attempted to create a romantic image of the turnpike was this image of the moon illuminating the "straightaway" just east of Blue Mountain Tunnel.

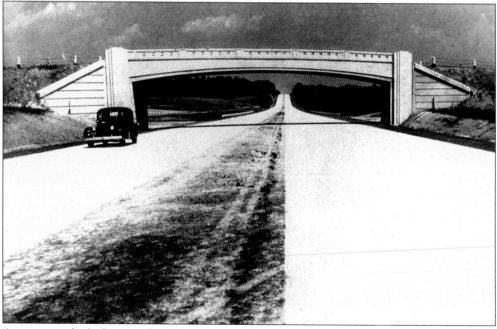

An unretouched photograph of the same bridge fails to convey the same mystique as the enhanced postcard view.

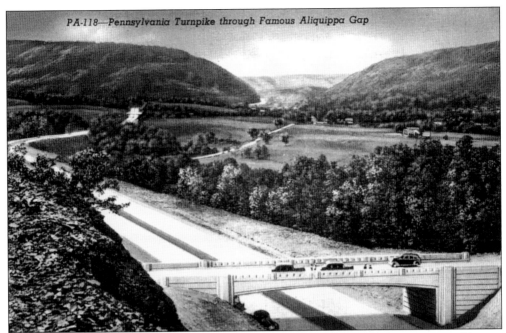

The westward view from atop Clear Ridge Cut, shown on this postcard, was among the very best and most frequently published images used by the turnpike commission and its vendors. A very similar photograph was printed in the photo essay entitled "Super-Highway," which appeared in the July 29, 1940, issue of *Life* magazine. The article previewed the soon-to-open highway.

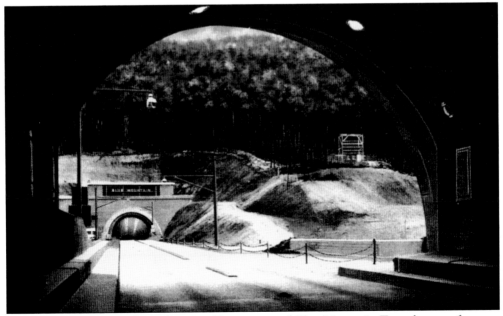

The short section of highway between Kittatinny and Blue Mountain Tunnels was a frequent subject of the series of postcards depicting the turnpike. The scene was always framed by the silhouette of the tunnel from which the photograph was taken.

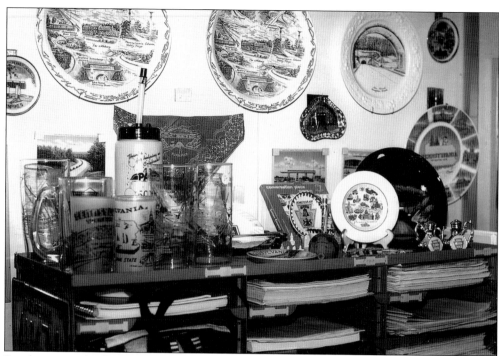

Besides postcards, the image of the turnpike was routinely captured on souvenir dinner plates, drinking glasses, ashtrays, and pennants, among others. This is just a part of chief turnpike bridge engineer Neal Wood's turnpike memorabilia collection. He proudly displayed them in his office at the turnpike commission's headquarters building in Harrisburg. (Mitchell E. Dakelman.)

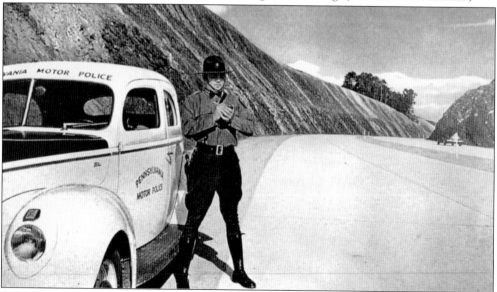

Advertisers, contractors, and suppliers all got in on the act of using the turnpike to promote their products. One of the suppliers of explosives used during the construction of the turnpike placed this advertisement in the official turnpike dedication book. Shown here are a state trooper and his cruiser deep in Clear Ridge Cut, which was blasted out of the mountain using the firm's dynamite. The top of the ad boastfully proclaimed, "No More Going 'Round the Mountain!"

As the years went on, the commission eventually stopped printing "the World's Greatest Highway" on its promotional material. Nevertheless, it continued to feature many of the classic images of the turnpike on its publications. A case in point is this brochure from the early 1960s. Shown again is the often used image of the short stretch of highway between Kittatinny and Blue Mountain Tunnels. This version features a tunnel guard on patrol.

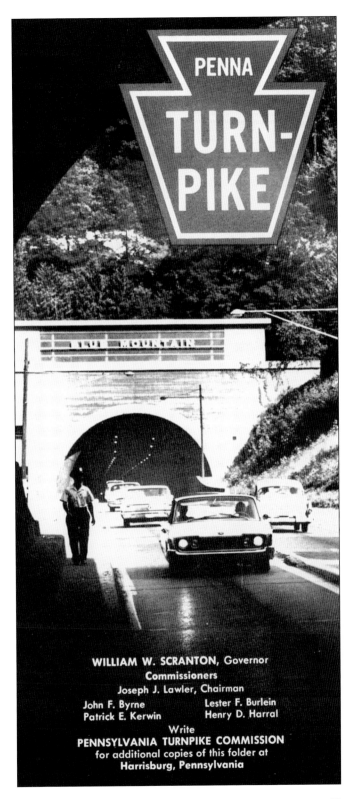

PENNA
TURN-PIKE

BLUE MOUNTAIN

WILLIAM W. SCRANTON, Governor
Commissioners
Joseph J. Lawler, Chairman
John F. Byrne Lester F. Burlein
Patrick E. Kerwin Henry D. Harral
Write
PENNSYLVANIA TURNPIKE COMMISSION
for additional copies of this folder at
Harrisburg, Pennsylvania

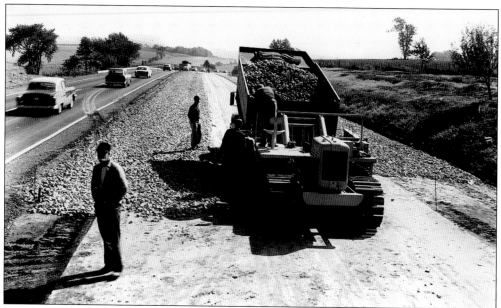

Not even the World's Greatest Highway could last forever. In fact, parts of the original concrete pavement began to crack and fail after only a few years. Beginning in 1954, a program was begun to resurface the entire length of the original turnpike. Shown here is a repaving operation near New Stanton in 1956. The project was completed by 1962.

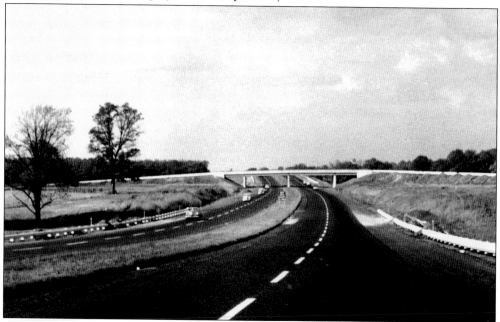

The ultimate legacy of the Pennsylvania Turnpike was not its slogans or souvenirs, but the revolution it began in American transportation. Its success as the nation's first long-distance superhighway spawned a multitude of toll roads, including the well-known New Jersey Turnpike, shown here in 1952. They in turn led to the creation of the Interstate Highway System, which has unquestionably changed the American way of life. Therein lies the true greatness of the Pennsylvania Turnpike. (Homer Hill.)

Five

SPANNING THE STATE

Commission chairman Walter A. Jones envisioned a network of superhighways spanning not only Pennsylvania but neighboring states as well. The first order of business was to authorize eastern and western extensions, even before the original turnpike opened in late 1940. The 100-mile-long Philadelphia Extension, linking Carlisle to Valley Forge, where a new state highway would connect to the city of Philadelphia, was created by Legislative Act No. 11 on May 16, 1940. The 67-mile-long Western Extension, linking Irwin to the Ohio border northwest of Pittsburgh, was authorized by Legislative Act No. 10 on April 15, 1941.

Jones would never see his dream come true, as he resigned his post due to illness in 1941 and passed away a year later at the age of 68. Replacing Jones as chairman of the turnpike commission was Thomas J. Evans, who had been appointed a commissioner in 1939. Evans, a Welshman from Coaldale, had risen from coal miner to superintendent and had both policy-making and executive experience.

World War II intervened, and expansion projects had to be placed on hold. After the war, construction began on the $87 million Philadelphia Extension following a groundbreaking in York County on October 28, 1948. It was opened to traffic on November 20, 1950. Construction on the $77.5 million Western Extension began on October 24, 1949, and it opened to traffic on December 26, 1951. The extensions used the basic design of the original turnpike, but the steepest grades were 2 percent rather than 3 percent, as they were on the original turnpike. Several major bridges were required for both extensions.

The original turnpike and extensions comprised the Pennsylvania Turnpike System. Other extensions throughout the state were planned, including a route connecting Harrisburg with Scranton, another to the Maryland border near Gettysburg, one to Lake Erie, and a parallel turnpike that eventually became the tax-supported and toll-free Keystone Shortway, known today as Interstate 80.

During the construction of the New Jersey Turnpike in 1950, plans were made by both states to connect the two highways. The $65 million, 34-mile Delaware Extension, from Valley Forge to Bristol, was completed on November 17, 1954, and the Delaware River Bridge connecting the Pennsylvania and New Jersey Turnpikes was opened on May 23, 1956. With the opening of new toll roads in Ohio, Indiana, and Illinois, by 1957 it was possible to drive from New York to Chicago without encountering a stoplight.

The Northeastern Extension, a 110-mile highway connecting the main line turnpike near Norristown along the Delaware Extension to Clarks Summit north of Scranton opened on November 7, 1957, but was never completed to the New York state line as planned. In 1956, Pres. Dwight D. Eisenhower's National Defense Interstate Highway Act was signed into law, and the remaining highways planned by the turnpike commission were built as tax-supported roads using federal funds.

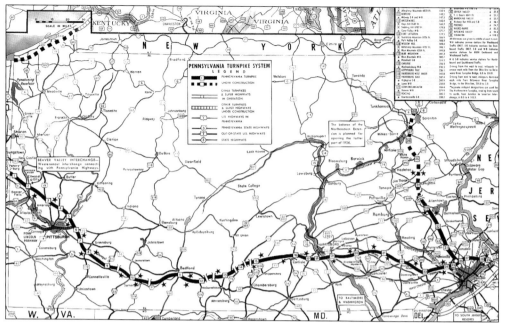

This 1955 Pennsylvania Turnpike map shows the original section of the turnpike, as well as the Philadelphia, Western, Delaware River, and Northeastern Extensions. The northern half of the Northeastern Extension is shown under construction. By the time it opened in 1957, the turnpike had expanded from its original length of 160 miles to a total of 470 miles. Plans for a 750-mile network, suggested by the "Northwestern Extension" near Erie, never materialized, due to the 1956 Federal Highway Act.

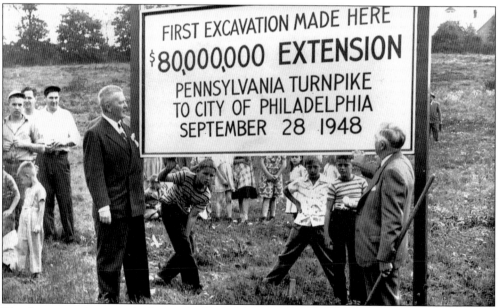

The first extension to be built was the Philadelphia Extension, linking the eastern terminus of the original section with Valley Forge in suburban Philadelphia. The groundbreaking ceremony was held on September 28, 1948, in York County. Gov. James Duff and commission chairman Thomas J. Evans flank a sign announcing the start of the project.

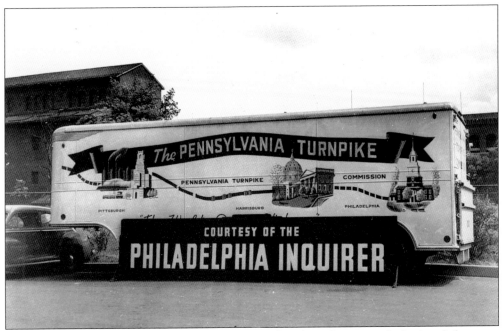

The Philadelphia Inquirer assisted with the groundbreaking festivities. It displayed the route of the original section, as well as that of both the Philadelphia Extension and the proposed Western Extension, on the side of this trailer.

Although the 100-mile Philadelphia Extension had its share of obstacles, it did not require the mammoth earthmoving operations of the original section. Here, scrapers have begun to grade the right-of-way for the new highway. Like the original section, it would feature four 12-foot concrete lanes separated by a 10-foot grass median. Its overall appearance would closely resemble that of the 1940 turnpike.

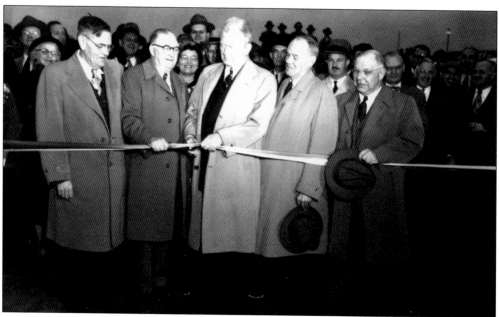

The Philadelphia Extension was completed in a little more than two years. Here, Gov. James Duff and commission chairman Thomas J. Evans meet again to cut the ribbon at the dedication of the new extension, which opened on November 20, 1950. The ceremony was held at the Valley Forge toll plaza. The barrier-type facility spanned the width of the highway several miles west of the new extension's terminus at U.S. Route 202 at King of Prussia.

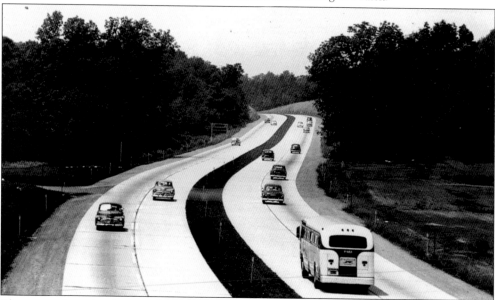

The extension closely resembled the original section, but it incorporated a number of engineering improvements. Newly developed air-entrained concrete was used because of its greater durability. Instead of simply pouring the concrete on compacted earth, a more stable stone base was used, and the transverse joints were now spaced every 46 feet rather than every 77 feet, as in the original turnpike. As a result, it would be 23 years until an asphalt overlay would be required.

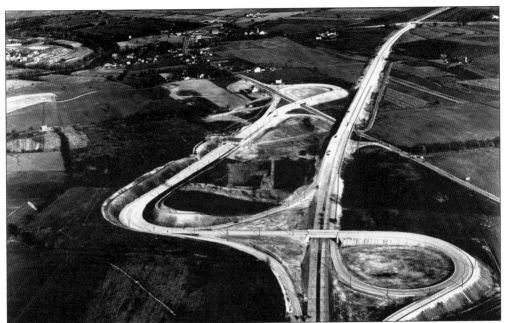

The original Carlisle interchange and tollbooth was closed with the opening of the Philadelphia Extension. The Middlesex interchange at U.S. Route 11 was reconfigured to accommodate all traffic movements and the new extension. It was redesignated as the Carlisle interchange and outfitted with a tollbooth. In this aerial view, Route 11 cuts diagonally across the photograph. The original section is located at the bottom of the photograph below Route 11, and the extension is toward the upper right.

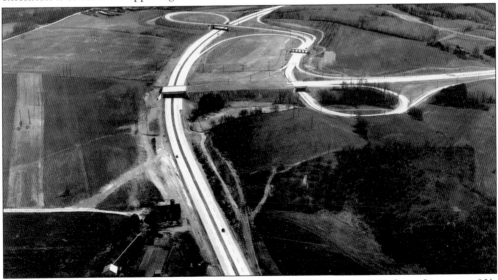

The Harrisburg West Shore interchange connected with U.S. Route 111 (now Interstate 83), which, prior to this time, had been a two-lane road connecting Harrisburg to York. Route 111 in the vicinity of the turnpike was reconstructed into a four-lane divided highway, concurrent with the construction of the Philadelphia Extension. When this photograph was taken, the reconstructed highway extended only as far as the interchange with the turnpike. The unopened Route 111 bridge over the turnpike is also complete.

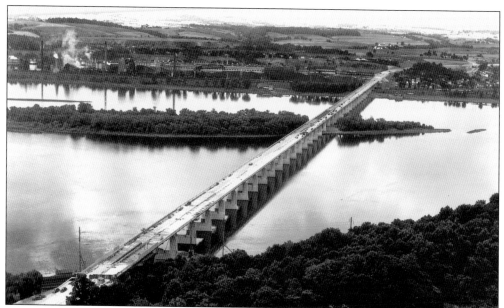

At 4,600 feet, the Susquehanna River Bridge was by far the longest bridge on the Philadelphia Extension, and it dwarfed any bridge ever built on the original section. This eastward view shows the bridge as it neared completion in 1950. The bridge crossed the shallow river on a slight skew. Its height was determined by the four-track Northern Central branch of the Pennsylvania Railroad, which was electrified by high-tension catenary wires.

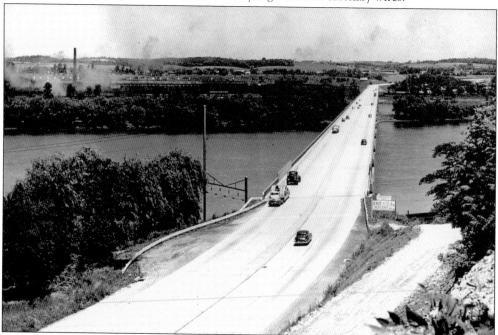

This is a view of the bridge after it was placed in service. In order to reduce the cost of the structure, it was built with a narrow 4-foot-wide raised concrete median instead of the standard 10-foot median width, and it did not have shoulders. This view was taken from the ridge on the southwestern shore of the river.

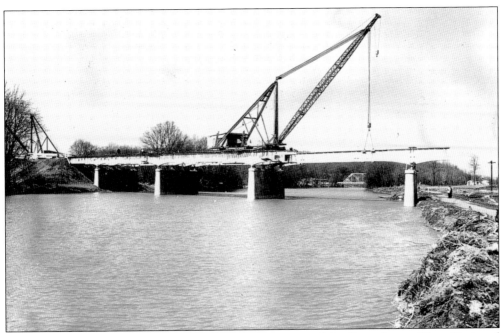

The Swatara Creek Bridge was the next large structure east of the Susquehanna River. Designed by Modjeski and Masters, the 611-foot-long bridge was located near Elizabethtown. Shown under construction in 1950, the slightly skewed bridge consists of six continuous girder spans, the longest being 117 feet 6 inches. The bridge was the second longest on the Philadelphia Extension.

Unlike the original section, the Philadelphia Extension crossed over railroads at numerous locations. This unique steel-and-concrete structure carried the turnpike over a branch of the Reading Railroad near Denver. It featured highly decorative masonry work, like many of the structures on the original section.

The Philadelphia Extension continued the practice of using concrete rigid-frame arch bridges and steel through-girder bridges for the overpasses. The type of overpass pictured here was new to the turnpike, not having been used on the original section. It is a steel deck bridge, consisting of steel girders supporting a concrete deck and parapets. (Mitchell E. Dakelman.)

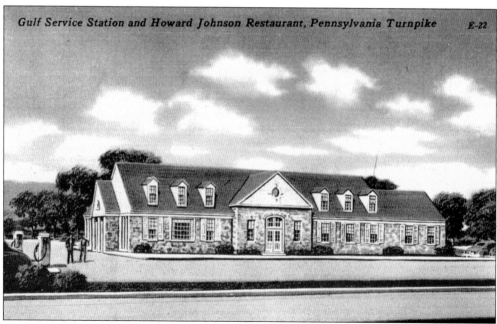

Gulf Service Station and Howard Johnson Restaurant, Pennsylvania Turnpike *E-22*

The service plaza buildings on the extension were much larger than those on the original turnpike. The one shown in this postcard view is typical. Compare it to the ones illustrated on page 60. They were placed back farther from the main line and sometimes at a higher elevation for safety reasons but were of the same general architectural style as those on the original section.

Gulf Oil, rather than Standard Oil (Esso), was chosen to operate the service stations on the extensions, though Howard Johnson's was again contracted to provide food service at the new plazas. The spacious dining room was elegantly appointed with paintings, wood paneling, and chandeliers. A full-service menu was the order of the day for a generation accustomed to the pleasures of leisurely dining.

This view of the service plaza lobby shows the cash register area in the center, the dining room entrance toward the right, and the gift shop to the left. Turnpike souvenirs can be seen in the curved, glass-enclosed display case below the cash registers, and a rack of postcards is visible to the left. Although the highway was 10 years old, turnpike souvenirs remained as popular as ever.

The Philadelphia Extension passed near the rich farmlands of Lancaster County, which was often referred to as the Pennsylvania Dutch country. Never missing an opportunity to promote the turnpike, Howard Johnson's and the turnpike commission frequently used the image of an Amish buggy crossing a turnpike overpass on postcards and publications in the 1960s.

When the Philadelphia Extension was opened, additional state police were assigned to the turnpike. Here one poses in front of an oversized speed limit sign. In addition to enforcing the traffic laws, they also regularly patrolled the highway to assist motorists in distress.

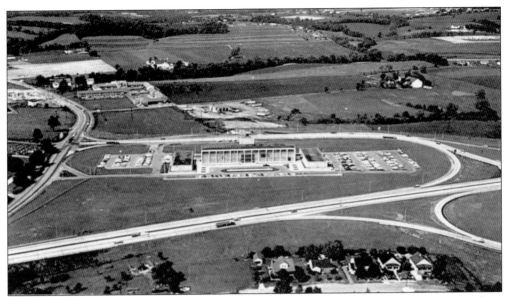

After the opening of the Philadelphia Extension, the turnpike commission relocated its headquarters from a cramped office in Harrisburg to a new facility located at the Harrisburg-East interchange.

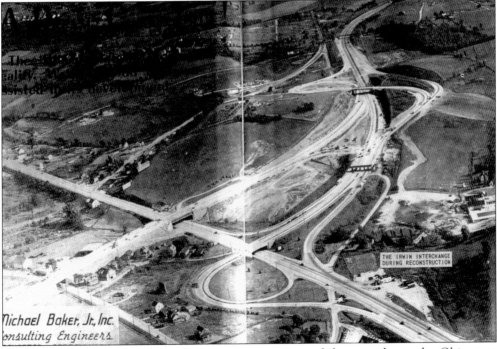

THE IRWIN INTERCHANGE
DURING RECONSTRUCTION

Michael Baker, Jr., Inc.
Consulting Engineers

The Western Extension relocated the western terminus of the turnpike to the Ohio state line. The groundbreaking ceremony took place on October 24, 1949. Here, a new trumpet interchange is being built at the junction of the original highway and the extension. The 1940 highway and tollbooths can be seen at the upper right and the mid-right. The interchange with U.S. Route 30 is located at the bottom center. The extension swings off to the lower left corner as it heads to the west.

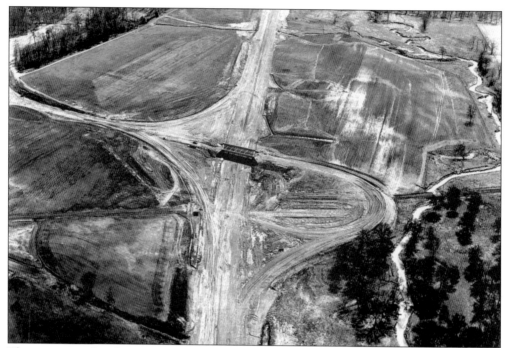

The trumpet style of interchange was used exclusively on all of the postwar extensions. The Perry Highway (now Cranberry) interchange was typical. The turnpike commission often coordinated the construction of the interchanges with the Pennsylvania Department of Highways, which was reconstructing many roadways in the early 1950s. Here, the right-of-way for the new U.S. Route 19 can be seen in the upper left-hand corner. U.S. Route 111, shown on page 89, was another example of such coordination.

The Allegheny River Bridge was the largest on the Western Extension and was nearing completion by August 1951. Several construction workers monitor the progress in this photograph, taken from Gulf Lab Road looking to the east. The Bessemer and Lake Erie Railroad bridge can be seen in the background, and the new turnpike bridge is to its right. The trumpet-style Allegheny Valley interchange is in the foreground. (Fred McLeod.)

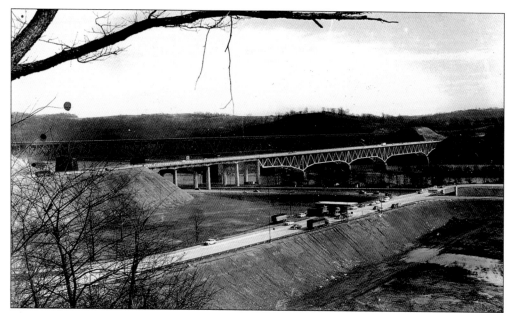

The Allegheny River Bridge was placed in service several months later, as seen here. At 2,180 feet in length, it was the second longest on the turnpike at the time of its completion. The Allegheny Valley interchange tollbooths shown in the foreground were constructed on a fill between the trumpet interchanges serving the turnpike and Pennsylvania Route 28. The state highway cuts across the picture below the two bridges. (Fred McLeod.)

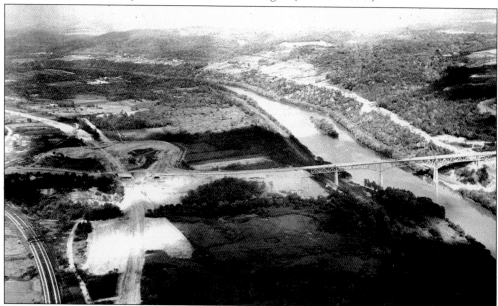

As it headed toward Ohio, the Western Extension crossed the Beaver River on a 1,540-foot-long bridge, the second longest on the new section. To the left, the Beaver Valley interchange is under construction. It connected the turnpike to the newly relocated Pennsylvania Route 18 in another example of coordination with the Pennsylvania Department of Highways. Its partially graded right-of-way is also visible toward the left. The tracks of the Pennsylvania Railroad are in the lower left corner.

The Western Extension began the widespread use of a much more modern style of overpass. These three-span structures were more open than their predecessors and were constructed atop a pair of utilitarian piers. The superstructure was built of either plate girders or rolled I-beam stringers. A concrete slab deck and short parapets topped by a steel pipe railing completed the structure. This type of overpass would become the standard design used in highway construction for the next 50 years.

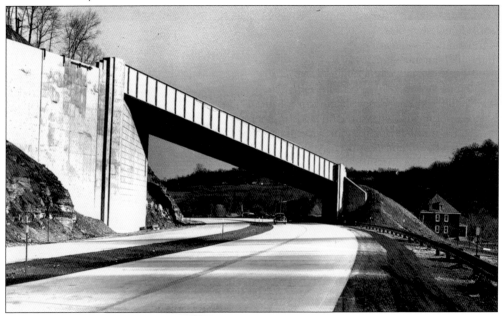

While embracing the new style of bridge illustrated above, the turnpike commission continued to use the durable steel through-girder design on the Western Extension. The hilly western Pennsylvania topography required many local highways near Pittsburgh to cross the turnpike on bridges built on steep grades and at extreme skews. This particular structure tested the bridge builder's art and was the most dramatic example of all such bridges. It carried Pennsylvania Route 910.

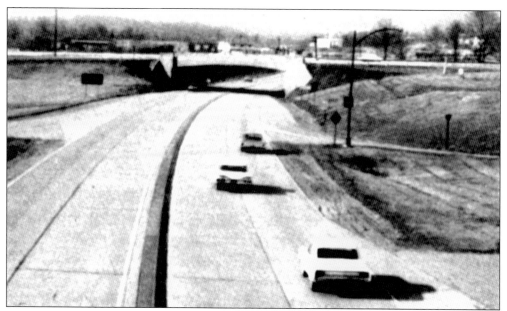

While many of the turnpike's signature concrete rigid-frame arch overpasses were used on the Philadelphia Extension, not a single one was constructed on the Western Extension. Just a handful were used to carry the turnpike itself over local highways, such as this one at the Beaver Valley interchange with Pennsylvania Route 18. With the completion of the Western Extension on December 26, 1951, this handsome style of bridge would never again be used on the Pennsylvania Turnpike.

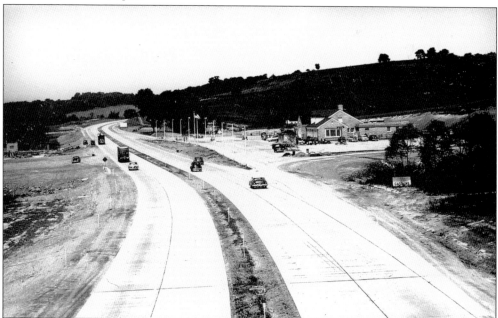

The Butler Valley service plaza was located just east of the Perry Highway interchange and was the last rest facility on the westbound turnpike before it left the commonwealth. Compare the size of this relatively large facility with that of the much smaller plazas built on the original section, such as Cove Valley illustrated at the bottom of page 60.

The guardrails used on all of the postwar extensions were a refined version of those used on the original section. The flat metal panels of the 1940 highway lacked rigidity and were subject to deflection and pocketing when hit by an out-of-control vehicle. The postwar design was ribbed to impart stiffness to the guardrail panels. It became the standard for highway design in the 1950s until supplanted by the W-beam guardrails introduced in the early 1960s.

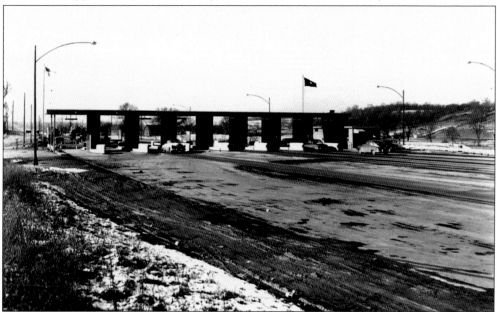

The Gateway toll plaza was located one mile east of the Ohio state line and became the western terminus of the turnpike after the completion of the Western Extension. Until the opening of the Ohio Turnpike several years later, traffic exiting the Pennsylvania Turnpike was directed onto rural highways and small towns in Ohio by means of a temporary ramp just west of the toll plaza. Compare its nine lanes with the four-lane 1940 Carlisle tollbooth on page 73.

The 33-mile Delaware River Extension was the next section of the turnpike to be placed under construction. Ground was broken for the project on November 20, 1952. The project extended the highway from Valley Forge to the western bank of its namesake river. Shown is an artist's rendering of the longest structure on the extension, the 1,224-foot Schuylkill River Bridge.

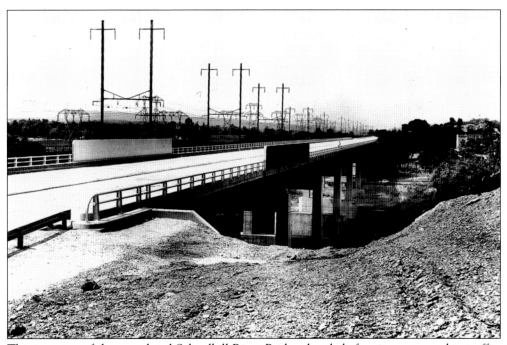

This is a view of the completed Schuylkill River Bridge shortly before it was opened to traffic. Like all of the major bridges on the turnpike, it lacked shoulders and used a narrow four-foot-wide raised concrete median to minimize construction costs. The Pennsylvania Railroad's electrified Trenton Cutoff, seen to the left, paralleled the turnpike in this area.

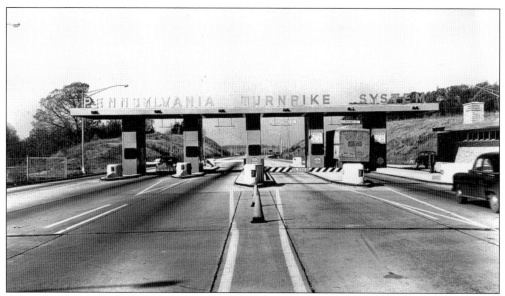

Construction of the Delaware River Extension necessitated the relocation of the barrier-style Valley Forge toll plaza several miles to the east, near the turnpike's junction with the Schuylkill Expressway. The relocated tollbooths can be seen in service in this image. A new feature of the toll facilities was the lettering spelling out "Pennsylvania Turnpike System" atop the structure, an expression indicative of the turnpike's ongoing expansion.

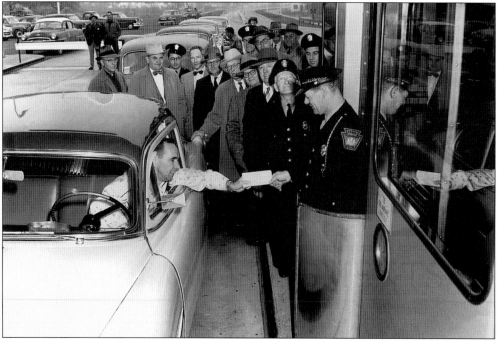

The Delaware River Extension was opened as far as the Fort Washington interchange on September 20, 1954. Here, turnpike commission officials and a toll collector pose for the photographer as the first motorist receives a toll ticket and prepares to enter the newly opened section of highway.

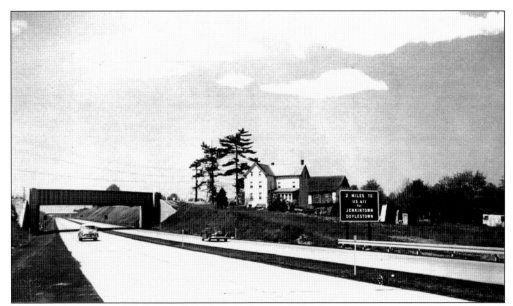

The balance of the new Delaware River extension opened on November 17, 1954. Although the highway and overpasses resembled the original 1940 highway, compare the utilitarian exit sign for U.S. Route 611 to the ornate one shown on the bottom of page 61. Traffic is light on the rural highway in this view. Over the next 40 years, the expanding Philadelphia suburbs would transform the road from a long-distance intercity route into a busy commuter highway.

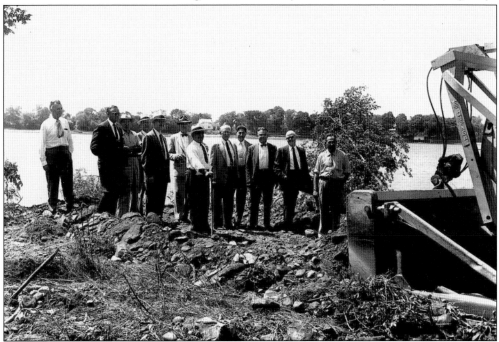

The final step in spanning the state was the construction of a bridge over the Delaware River, which was designed to connect the Pennsylvania Turnpike with the recently opened New Jersey Turnpike. Groundbreaking ceremonies took place on June 26, 1954, in Florence, New Jersey.

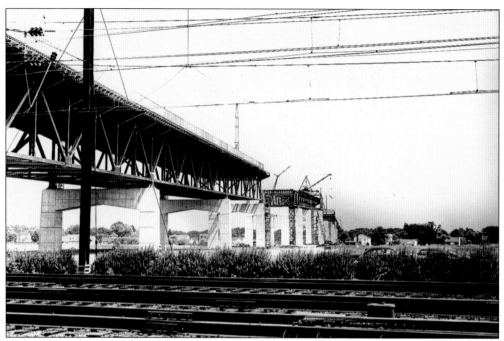

In this view of the Delaware River Bridge, the concrete piers have been completed, and structural steel is being erected for the approaches to the main river crossing. The plans for the main channel structure called for a tied arch, a design popular at the time. Erection of the structural steel for the arch had not yet begun at the time this photograph was taken.

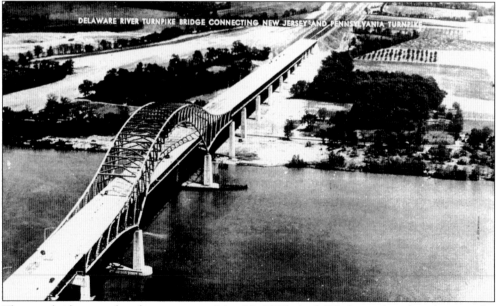

The new bridge was placed in service on May 23, 1956. At 6,571 feet in length, it became the longest bridge on the turnpike. The steel arch bridge was the work of George Richardson, who also designed the Beaver River Bridge. Unlike the rest of the turnpike, the bridge was six lanes wide and lacked a median between lanes of opposing traffic. Eventually, a median barrier was installed and the bridge was narrowed to just four lanes.

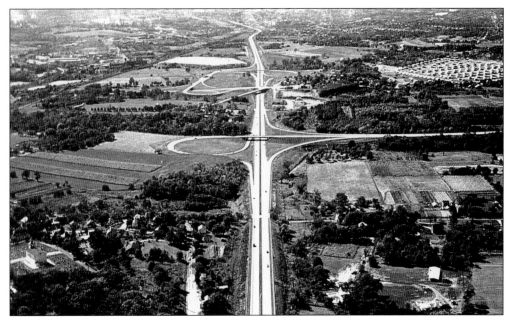

With the completion of the east–west turnpike, the commission turned its attention to reaching other parts of the commonwealth. On March 24, 1954, work began on the Northeastern Extension, a route designed to connect the existing highway with Scranton in northeastern Pennsylvania. The trumpet interchange that connected the new route with the east–west highway is visible in the center. The Norristown interchange is at the top center.

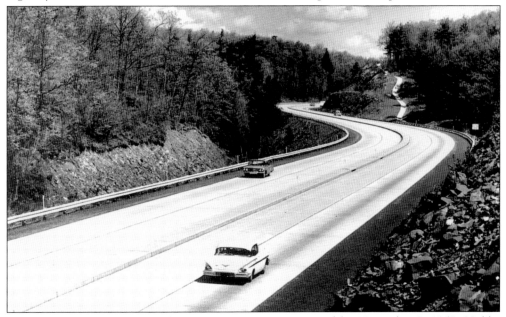

The entire length of the Northeastern Extension was opened by November 7, 1957. Unlike the east–west turnpike, it had a narrow four-foot median. At a time when new highways across America were being built with increasingly wider medians, the commission chose a narrower one to reduce the cost of the road. Initially, traffic on the road was light, and it would be many years before the tolls collected on the extension were sufficient to cover the costs of construction.

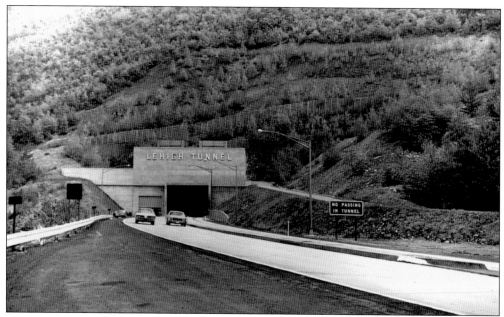

The solitary tunnel on the Northeastern Extension was the 4,461-foot Lehigh Tunnel. Like those on the original section, it too was built with just two lanes, although it had white tile walls and much brighter continuous fluorescent lighting. At first, the tunnel was to be named for commission chairman Thomas J. Evans. When he was convicted of conspiracy to defraud the turnpike commission of $19 million on July 25, 1957, the name of the tunnel was quickly changed.

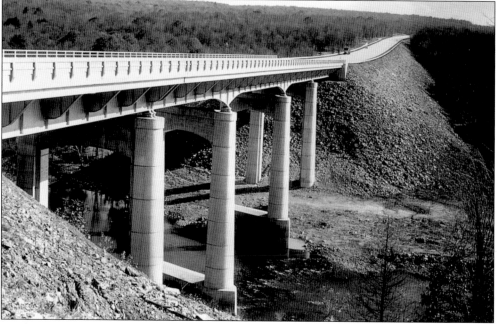

North of the Lehigh Tunnel, the Pennsylvania landscape changed from hilly to mountainous as it entered the Poconos. As a result, considerable earthwork was required, as were a number of large structures. The Hickory Run Bridge shown here is typical of those on the Northeastern Extension.

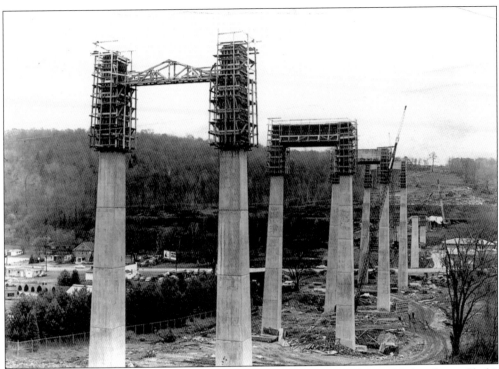

The northernmost bridge on the Northeastern Extension was the 1,632-foot-long Clark's Summit Bridge. It carried the highway over U.S. Routes 6 and 11, and at 135 feet in height, it was the highest structure on the entire turnpike system. The piers for the bridge are shown under construction in this view.

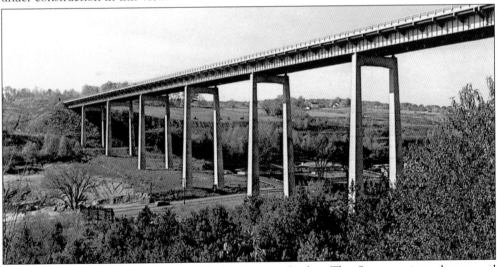

This is an image of the completed Clark's Summit Bridge. The Scranton interchange and the terminus of the Northeastern Extension were located at the northern end of the bridge. The intention of the turnpike commission was to extend the highway to the New York state line. However, with the federal legislation authorizing construction of the Interstate Highway System, the expansion of the turnpike came to an abrupt end. It would be several decades until the turnpike would again be extended.

The unrealized plans of the turnpike commission are evident in this photograph showing the Clark's Summit Bridge and the northern terminus of the Northeastern Extension. The northbound off-ramp, which was "temporarily" widened to two opposing lanes, can be seen at the lower left-hand corner of the image. To its right is a small spur that is the incomplete northbound main line, which was to continue to New York State. Instead, the balance of the highway was built as Interstate 81.

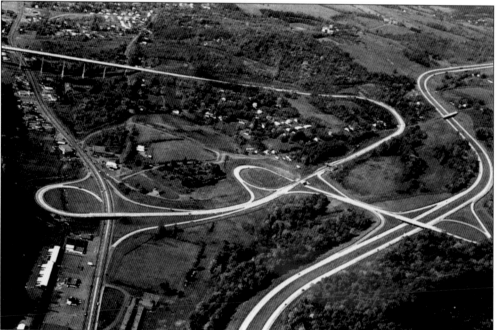

In this aerial view, the Northeastern Extension and Clark's Summit Bridge may be seen entering the photograph in the upper left-hand corner. Interstate 81 is heading north toward New York State at the upper right. The original plans of the turnpike commission called for the turnpike to proceed in a route across the top of the photograph and follow the alignment used by Interstate 81. Instead, a pair of connected trumpet interchanges was constructed to link the two highways.

Six

FOUR LANES
ALL THE WAY

Although the work on the original section of the Pennsylvania Turnpike and its extensions was finished by 1957, in a sense, one final project remained to be completed. The engineers who designed the original section of the Pennsylvania Turnpike were well aware that the seven tunnels really should have accommodated four lanes. Bowing to financial realities, as well as projections of fairly light traffic, the new express highway was constructed with single-tube tunnels, each providing just two lanes. As time went by, the highway attracted more vehicles year after year. By the 1950s, traffic jams began to develop at Laurel Hill Tunnel during the peak summer travel period. Over the next few years, the situation began to affect the other tunnels as well, with the delays becoming longer with each passing year. The tunnels that had initially captured the public's imagination were now the source of its ire.

It became obvious to the turnpike commission that something had to be done. After studying the problem, the commission elected to construct new parallel tubes at four of the tunnels. The remaining three were to be bypassed altogether.

The first project to be completed was the Laurel Hill Bypass, opened on October 30, 1964, which rerouted the turnpike to the north by means of a new roadway built through a deep cut in Laurel Hill. The next bottleneck to fall was Allegheny Tunnel. Here, the engineers decided to construct a new parallel tunnel to the south of the existing tube. It opened on March 15, 1965. Thereafter, the original tunnel was shut down and completely modernized. Similarly, new parallel tunnels were opened at Tuscarora, Kittatinny, and Blue Mountain Tunnels on November 26, 1968, followed by rehabilitation of the original tubes.

The solution for Rays and Sideling Hill Tunnels would be very different. The engineers evaluated a route considered for the turnpike in the late 1930s that would have carried it over the two mountains, rather than boring through them. Deemed too expensive and impractical at the time, by the 1960s this option appeared to be quite viable. This proposal was compared to the option of double-tunneling Rays and Sideling Hill Tunnels. After a thorough engineering analysis, it was felt that rerouting the turnpike over the two mountains was the preferable option.

The bypass opened on November 26, 1968, and resulted in the relocation of over 13 miles of the original turnpike. Cove Valley service plaza was closed and replaced by the new Sideling Hill service plaza. The Breezewood toll plaza was moved to the west, and a one-mile stretch of the original turnpike was used as a spur to reach U.S. Route 30. After almost three decades, the entire original section of turnpike was four lanes, and the dreams of its creators were completely realized. The abandoned section of highway gradually succumbed to both Mother Nature and vandals, and gained the distinction of being the longest abandoned expressway in the United States, if not the world.

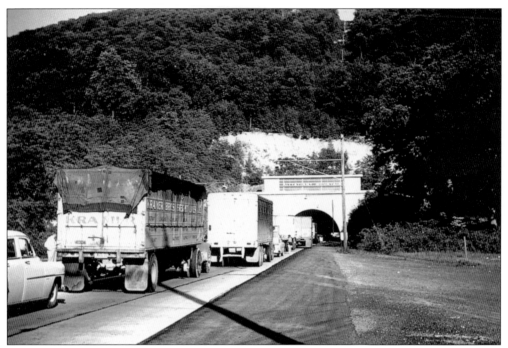

As traffic increased on the turnpike in the 1950s, traffic jams began to occur at the two-lane tunnels with increasing frequency. The problem became particularly acute during the summer vacation months. The problem is obvious in this photograph, taken at the west portal of Kittatinny Tunnel on July 12, 1952. (Charles Houser.)

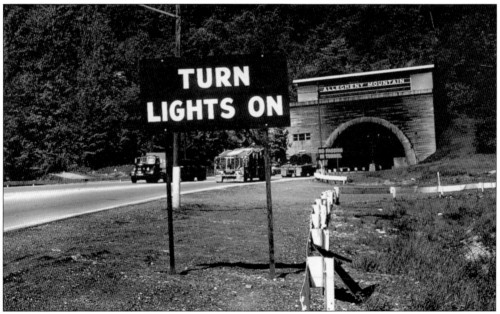

Motorists were given a variety of warnings as they approached the narrow and dimly lit tunnels. A series of signs painted in every color of the rainbow advised drivers to remove their sunglasses, not to pass in the tunnels, and to turn on their headlights. The whole assemblage of signs was referred to as "a crazy countdown" by one Pittsburgh newspaper.

Traffic congestion was most severe at Laurel Hill Tunnel. As a result, it was the first bottleneck to be addressed. The engineers chose to bypass the tunnel by means of a deep cut through the mountain to the north. It was placed in service on October 30, 1964. The bypass was the first section of the turnpike to feature climbing lanes for slow-moving trucks and a wide grass median. The western end of the bypass is shown here.

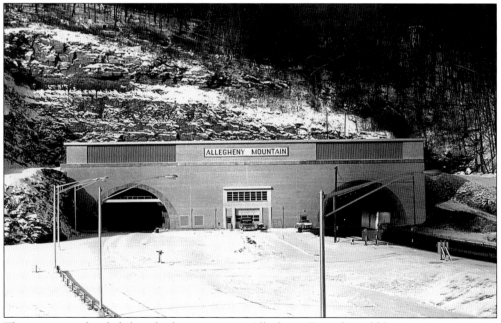

The engineers decided that the best option at Allegheny Tunnel would be to construct a new parallel bore. Work began on September 6, 1962, with the tunnel opening to traffic on March 15, 1965. Thereafter, the original tunnel was closed for 17 months so that it could be modernized with fluorescent lighting, tile walls, and a new road surface. Work on the new parallel tunnel was nearly complete when this view of the eastern portal was taken in December 1964.

111

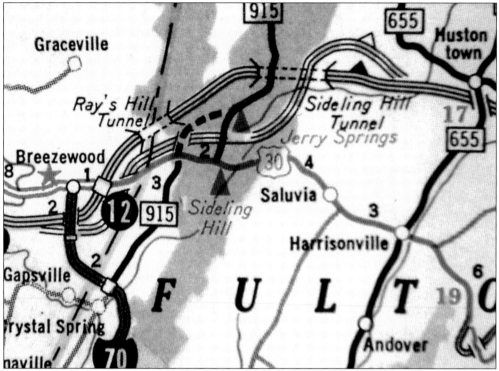

Heading east, Rays and Sideling Hill were the next two tunnels. A 13-mile bypass was chosen as the preferred method of alleviating this bottleneck. The route of the new Rays/Sideling Hill Bypass can be clearly seen on this Pennsylvania Department of Highways map published in 1967. The two tunnels, Cove Valley service plaza, and the under-construction Sideling Hill service plaza are all evident.

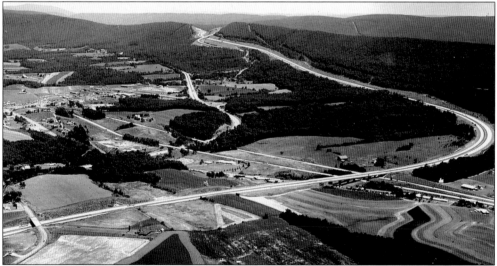

This is an aerial view of the western end of the Rays/Sideling Hill Bypass. The new bypass crosses over Interstate 70 in the foreground. The U.S. Route 30 overpass and the cut carrying the rerouted turnpike through the summit of Rays Hill are at the top center. The original turnpike may be seen at the center of the image. A portion of it was retained as a spur into Breezewood.

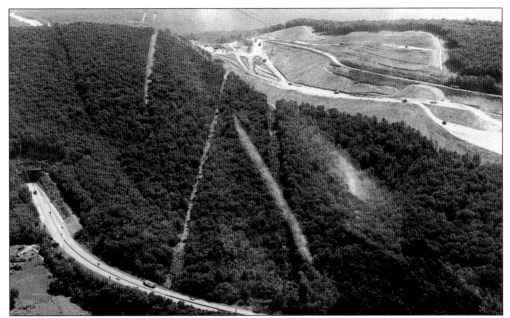

The still operational Rays Hill Tunnel and 1940 turnpike are to the bottom and left of this photograph. High atop Rays Hill, toward the top and right of the image, work has begun on the new bypass. Excavating crews have already torn a large gash through the top of the mountain to accommodate the new road. U.S. Route 30 can be seen winding through the back of the work area prior to its relocation.

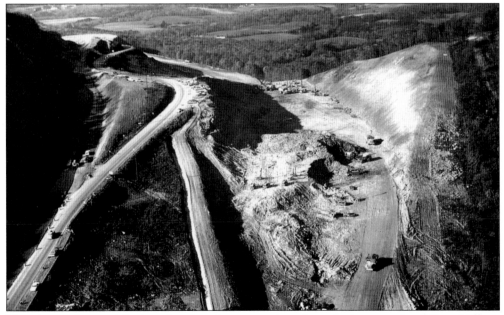

Here is another aerial view showing the excavation through the summit of Rays Hill on October 24, 1967. At the extreme left is a smaller cut that will accommodate the relocated U.S. Route 30, seen curving just to the right of its future alignment. To the right is the main cut where the new Rays/Sideling Hill Bypass will be constructed. The still operational Rays Hill Tunnel is off to the right, several hundred feet below the cut.

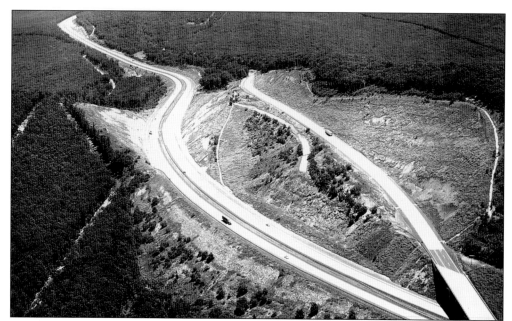

This image shows the summit of Rays Hill after work was completed. The now open bypass may be seen to the left, and the relocated U.S. Route 30 is to the right. It passes over the turnpike by means of a new bridge in the extreme lower right corner. A small abandoned segment of the original Route 30 can be seen between the turnpike and the relocated Route 30.

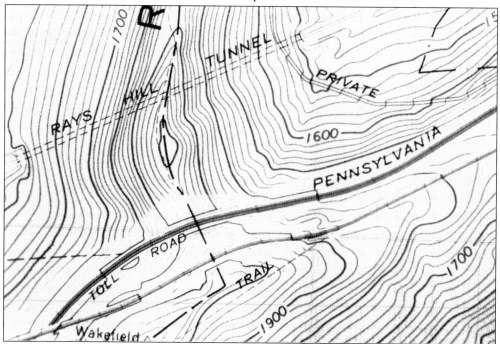

A U.S. Geological Survey map reveals the relationship between the bypass, Rays Hill Tunnel, and the original turnpike. The abandoned highway and tunnel can be seen at the top of the map, with the relocated highway lying just to the south. The road toward the bottom of the map is U.S. Route 30. (U.S. Geological Survey.)

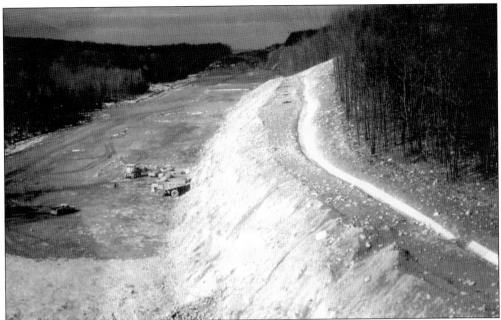

To the east, the new bypass began its descent down the eastern slope of Sideling Hill. Grading was nearly finished, but paving operations had yet to begin. Climbing lanes were provided for slow-moving trucks because of the 3 percent grades on either end of the bypass. A drainage trough to prevent water from running down and eroding the face of the cut may be seen to the right.

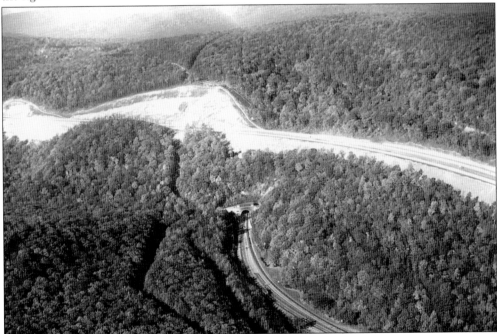

Sideling Hill Tunnel's days were numbered when this photograph was taken in October 1967. The new bypass was located directly above the tunnel's eastern portal, and the concrete roadway had already been poured.

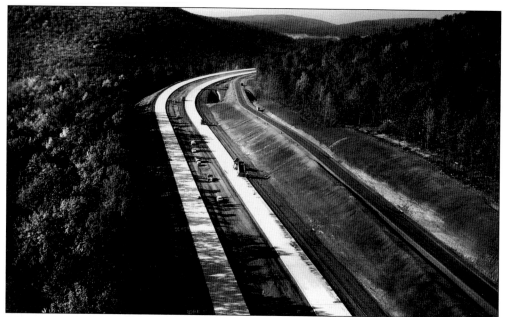

The eastern descent down Sideling Hill was nearing completion by October 27, 1967. Unlike the original turnpike, the new bypass had a modern 36-foot-wide median. Nevertheless, a steel barrier would be placed in the median in keeping with the turnpike commission's policy of installing a barrier the entire length of the highway.

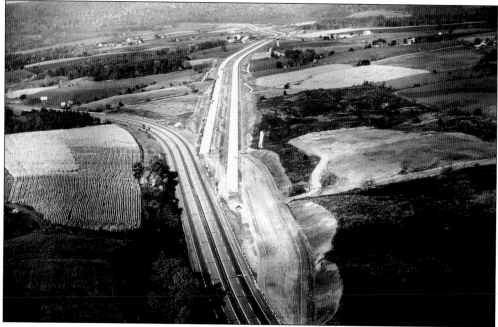

The eastern end of the new bypass tied into the existing turnpike east of the soon-to-be-closed Cove Valley service plaza. The bridge that allowed eastbound traffic to serve the plaza's replacement (the Sideling Hill service plaza) can be seen at the top center of the photograph. It is the only facility ever built on the east–west section of the turnpike that serves motorists traveling in both directions.

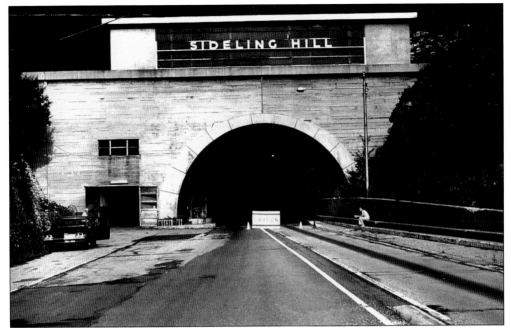

For a few years after their closure, Rays and Sideling Hill Tunnels were maintained by the turnpike commission, as evidenced by this photograph taken in August 1970. Having no further use for them, the commission eventually shut off the electricity, discontinued regular maintenance, and left the tunnel's fate to Mother Nature and vandals.

The abandoned section of highway gradually deteriorated. Guardrails, signs, and the median barrier were all removed. By 1990, some 22 years after its closure, the asphalt surface was crumbling away, and trees were growing in the median. However, the turnpike tested their pavement-marking equipment and performed some very basic maintenance on this stretch in order to keep it passable for use by turnpike maintenance crews and the state police. (Neal A. Schorr.)

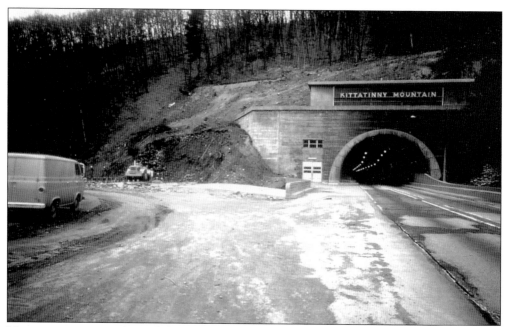

Mountainous topography and the alignment of the turnpike made the construction of a bypass impossible at Tuscarora, Kittatinny, and Blue Mountain Tunnels. Instead, a decision was made to build new parallel tunnels. In this 1967 view, work has just begun on the eastern end of the new Kittatinny Mountain Tunnel. Most of the tunnel boring was actually conducted from the western portal to avoid polluting the stream between Kittatinny and Blue Mountain Tunnels.

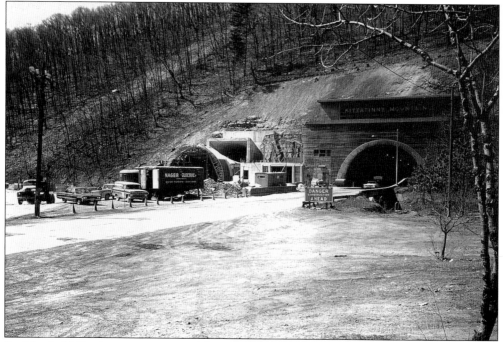

By March 1968, the concrete tunnel liner had been completed at Kittatinny Tunnel. Here, forms are being erected prior to pouring the concrete that will create the eastern portal itself.

118

The eastern portal of Kittatinny tunnel was nearing completion by July 1968. Work is progressing on the integration of the original and new fan houses, and the lighting standards have already been erected over the new eastbound lanes. The original tunnel, shown to the right, continues to carry two-way traffic.

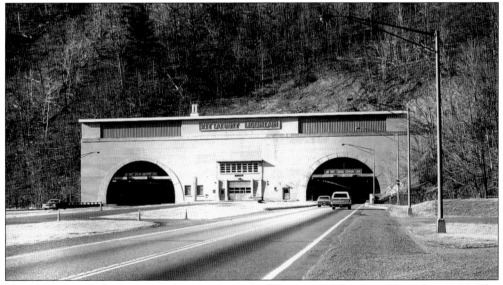

This is a view of the completed eastern portal of Kittatinny Mountain Tunnel c. 1985. The designers of the new tunnels did a masterful job of integrating the new and old tubes by retaining the concentric ring design of the original tunnel. The result was an architecturally pleasing design. With the completion of the new tunnels in 1970, the entire turnpike, with the exception of the Lehigh Tunnel on the Northeastern Extension, was at last four lanes wide. (Mitchell E. Dakelman.)

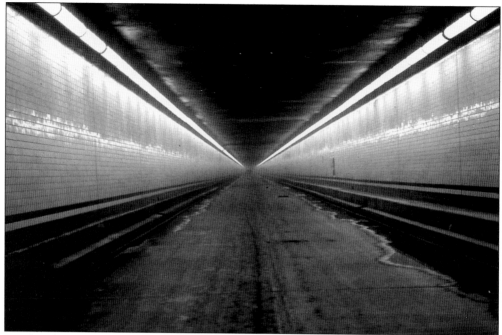

Unlike the original tunnels, both the new and rehabilitated tubes featured bright continuous fluorescent lighting and easy-to-clean white tile walls. At 13 feet wide, the traffic lanes in the new facilities were 18 inches wider than those in the 1940 tunnels.

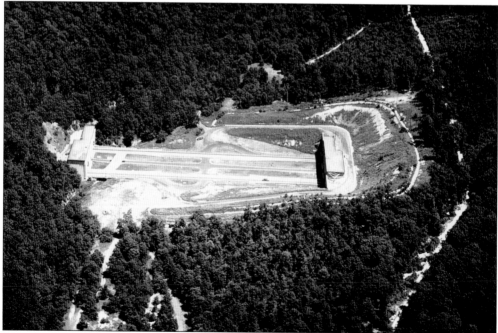

This aerial view of Gunter's Valley between Kittatinny and Blue Mountain Tunnels was taken after the completion of the new parallel tunnels. It illustrates the short distance between the two tunnel portals. This is the area that was the subject of the postcard view at the bottom of page 81 and the turnpike publication on page 83.

Seven

THE TURNPIKE
SINCE 1970

By 1970, the Pennsylvania Turnpike was three decades old. While the commission may have still regarded the road as the World's Greatest Highway, the moniker was more of a tradition than a statement of fact. Along with the correction of the tunnel problem, the commission had been working on the turnpike's now substandard 10-foot-wide median. A steel median barrier, initially used in curves and in high-accident areas, was completed along the entire length of the highway by 1970.

Traffic volumes continued to increase at a rapid rate, to a large extent the result of being fed additional traffic by the new Interstate Highway System. Unfortunately, the interstate highways built by the commonwealth often lacked a direct connection to the turnpike, resulting in serious congestion on the highways connecting the turnpike to the interstates. The most notorious of these was at Breezewood, where the main line of Interstate 70 was forced through the heart of the Breezewood commercial strip. While a number of direct connections have since been made, many remain unconnected to this day.

With the completion of Interstates 80 and 81, traffic volumes increased on the Northeastern Extension. Originally regarded as the albatross of the Pennsylvania Turnpike System, the increasing traffic eventually overwhelmed the single-bore Lehigh Tunnel. Like its seven 1940 counterparts, the tunnel received the addition of a second bore by 1991.

Meanwhile, having completed the interstates and other highways by means of floating bonds, the Pennsylvania Department of Transportation found itself in financial ruin by the 1970s. Unable to fund new highways, the state legislature passed Act 61, which directed the Pennsylvania Department of Transportation's "rich uncle," the Pennsylvania Turnpike Commission, to construct new toll highways throughout western Pennsylvania. As a result, the long-missing central section of the Beaver Valley Expressway northwest of Pittsburgh was the first new highway to be finished under Act 61. The Greensburg Bypass and half of the Mon-Fayette Expressway were the next to open. Planning continues for the balance of the Mon-Fayette and a Southern Beltway around Pittsburgh.

As work progresses on the extensions, the commission has embarked on a program to reconstruct the original 160 miles of the turnpike. The work includes the removal and replacement of the original roadway, as well as the rehabilitation or replacement of all bridges. Most significantly, the narrow 10-foot median is being widened in many locations to alleviate the turnpike's most longstanding shortcoming.

There have been numerous other improvements over the years. These include the widening of the turnpike to six lanes in suburban Philadelphia, construction of truck climbing lanes, widening and replacement of bridges, modernization of the toll collection system, and upgrading of the service plazas. While all have improved the turnpike, they have also caused it to lose much of the character, charm, and mystique that it possessed when first opened. Only the abandoned section east of Breezewood remains frozen in time, reminding us that in 1940, the Pennsylvania Turnpike really was the World's Greatest Highway.

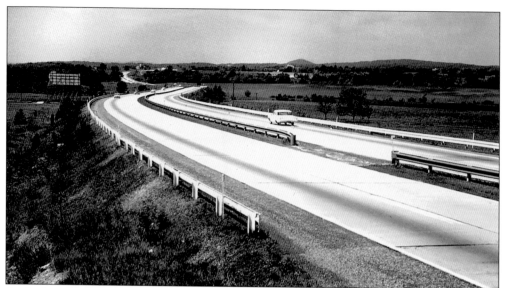

Aside from the dingy two-lane tunnels, the turnpike's narrow median proved to its biggest headache. Considered generous in 1940, by 1960 it was felt to be dangerously narrow, resulting in deadly head-on collisions. Beginning in the 1950s, the commission began to erect a steel median barrier on curves and in high-accident areas. By 1970, the barrier was extended throughout the length of the turnpike, including the Northeastern Extension with its even narrower four-foot median.

As intercity traffic increased, roadside oases of restaurants, gas stations, and hotels began to develop at many of the interchanges. Along the turnpike, Breezewood became the most famous of all. Because there was no direct connection between the turnpike and Interstate 70, the short stretch of U.S. Route 30 between them became clogged with roadside businesses and traffic. What had been a sleepy little town in 1940 became a busy commercial crossroads by 1970. (Neal A. Schorr.)

By the 1980s, the growth of suburban Philadelphia changed the eastern end of the turnpike from a rural city bypass into a busy commuter highway. Because of the burgeoning volume of traffic, the turnpike commission widened the section between the Norristown and Philadelphia exits to six lanes. A number of interchanges, including the one shown here with the Northeastern Extension, were completely reconfigured or reconstructed. As a result, the entire character of the highway was forever changed. (Neal A. Schorr.)

Although the seven tunnels on the original turnpike were all widened or bypassed in the 1960s, Lehigh Tunnel on the Northeastern Extension remained as a single-tube facility due to lower traffic volumes. By the 1980s, it too became inadequate to handle traffic. A second parallel tube was opened in 1991. Unlike the original tunnel, the new bore featured a round portal, resulting in an unusual asymmetrical architectural design. (Mitchell E. Dakelman.)

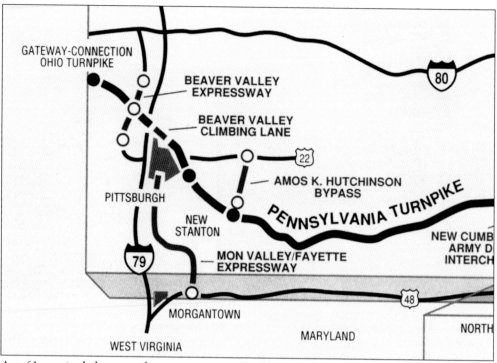

Act 61 required the turnpike commission to build a number of new expressways, mostly in western Pennsylvania. The first three to be built were the Beaver Valley Expressway (Toll 60), the Greensburg (Hutchinson) Bypass (Toll 66), and the Mon-Fayette Expressway (Toll 43). Over half of the Beaver Valley Expressway had been built by the Pennsylvania Department of Transportation, but the middle section had never been completed. The other two had been on the drawing boards for years, with little work ever having been completed.

The new extensions were completely modern in design and bore little resemblance to the original turnpike, with its narrow median and old-fashioned bridges. Aside from the toll barriers, the Pennsylvania Turnpike Commission's "PTC" logo, which was molded into the bridge parapets, was one of the few signs that the highway was actually owned by the Pennsylvania Turnpike Commission, not the Pennsylvania Department of Transportation. This is the Beaver Valley Expressway, shown under construction. (Neal A. Schorr.)

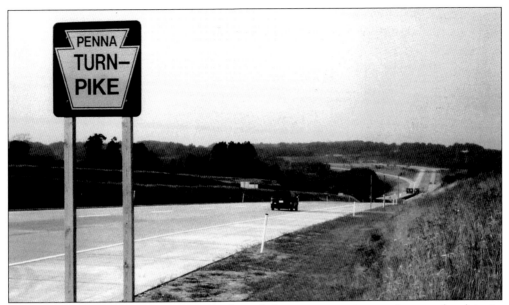

The Beaver Valley Expressway was the first of the new extensions to be completed in its entirety, opening to traffic on November 20, 1992. Shown here is its northern terminus, with Route 60, constructed by the Pennsylvania Department of Transportation, in the distance. The Greensburg Bypass would open a little more than a year later. Ten years later, roughly half of the Mon-Fayette was in service. Even the square turnpike trailblazer with its white background differs from those typically used on the original turnpike. (Neal A. Schorr.)

As work progressed on the extensions, it was becoming increasingly obvious that the 1940 section of the turnpike was nearing the end of its life. The old concrete bridges were deteriorating rapidly, and the asphalt overlays lasted only a few years on the unstable concrete base. Therefore, the commission embarked on a program to entirely reconstruct the original highway as it neared its 60th anniversary. This sign commemorates the first section to be reconstructed, located between Somerset and Donegal. (Neal A. Schorr.)

Even before the announcement of a formal reconstruction program, work had begun to replace the concrete center-pier bridges. The least durable of the three types of overpasses on the original highway, they were the first to be replaced. As shown on this bridge west of Bedford, each of the concrete T-beam spans was removed first. Then, the center pier and abutments were demolished. (Neal A. Schorr.)

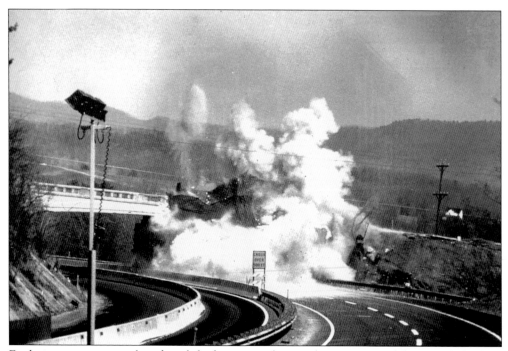

Explosives were required to demolish the more substantial concrete rigid-frame arch bridges. This bridge carried Route 655 over the turnpike near Hustontown.

Although some of the durable steel through-girder bridges could have been economically repaired, the widening of the median required their removal as well. The center pier is all that is left of the skewed overpass carrying Route 31 over the turnpike just east of Somerset. Compare this to the photograph of the bridge when brand new at the bottom of page 51. Contemporary travelers were able to gain some sense of what the structure looked like during its construction. (Neal A. Schorr.)

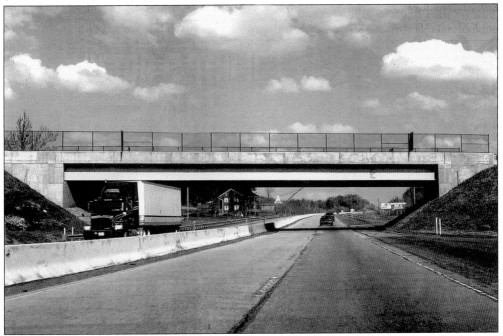

The original overpasses helped impart the unique character of the 1940 Pennsylvania Turnpike. Their replacements are utilitarian structures, such as this one a few miles east of Somerset. (Mitchell E. Dakelman.)

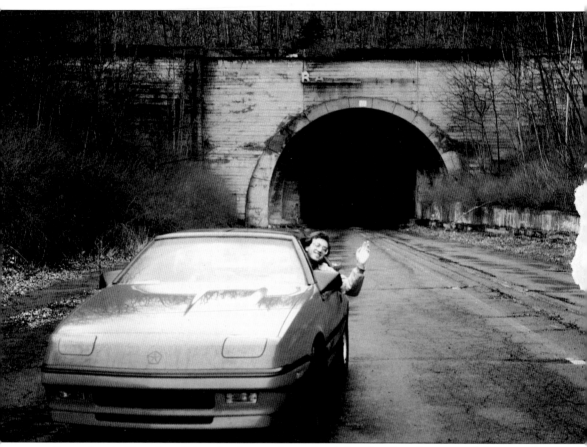

Pennsylvania Turnpike aficionados frequently explored the abandoned section of the turnpike after its closure in November 1968. This photograph was taken at the eastern portal of Rays Hill Tunnel close to a quarter-century after the tunnel's abandonment. Compare it to the 1940 image of the brand-new tunnel on the bottom of page 72. A visit to the abandoned stretch of highway can still give a sense of what the Pennsylvania Turnpike was like when it opened on October 1, 1940. With the leasing of much of the unused section to the Southern Alleghenies Conservancy in 2001, the longest stretch of abandoned expressway in America is now easily accessible to hikers, bikers, and fans of the World's Greatest Highway. (Mitchell E. Dakelman.)